THIS BOOK BELONGS TO

This book is for all my new friends
I have gained through sharing
my doodles and journal pages

Doodle Days

OVER 100 CREATIVE IDEAS for DOODLING, DRAWING, AND JOURNALING

Jane Maday

NORTH LIGHT BOOKS

NORTH LIGHT BOOKS

An imprint of Penguin Random House LLC
penguinrandomhouse.com

ISBN 9780593331873
eBook ISBN 9780593331880
Kindle ISBN 9780593421932
Nook ISBN 9780593421949

Printed in the United States of America
1st Printing

Book design by Ashley Tucker

Contents

DOODLING

LET'S GET STARTED

START WITH INEXPENSIVE SUPPLIES

Draw in pencil first

GET **IDEAS** FROM THE INTERNET

RELAX

Start simple THINK ABOUT YOUR GOALS

Introduction

Doodling is a fun and useful activity—a great addition to any journal or sketchbook, and it's the perfect activity to ignite your creativity! Daily doodling will inspire you and broaden your imagination (and even help you focus and become more expressive), making every day a world of new possibility and wonder. From cultivating fresh ideas when you're feeling stuck, to embarking on the sweetest escape from a bout of stress putting pen to paper is such a welcome respite from our digital world.

I doodle in my journal as a form of self-care and have been doing so for many years. I sketch within the pages in my bullet journal, on recipes, or grocery lists—anything that will make in my day a place where I am free to relax and unwind. There are no expectations or "rules" or need for comparison from insecurity. Remember, this is a process just for YOU, to help you relax and have fun. That's all. It takes a while to develop a habit, but once you get accustomed to drawing and thinking creatively, you'll wonder how you ever did without it!

How to Use This Book

This book is intended to be a creative compendium packed with pages of designs and inspiration for your journals and sketchbooks. The designs vary in difficulty, from easy to very difficult, so whether you are a beginner or a pro with your pencil, there is something here for everyone. This book is meant to help you find confidence in your own unique creativity and liftoff into a world of self-expression.

As you go through these pages, you'll find that I have included doodles in every category, from animals to seashells, and so many shapes in between. Each of those pages has a companion page where I outline step-by-step instructions. For the other drawings—your doodle library—you can copy them, trace them, or photocopy and paste them into your journal. You can even cut them out of the book if you like! When you attempt the drawings, draw with a pencil first. After the drawing is complete, go over it with a pen, and erase the pencil marks once the pen lines are dry.

The second part of this book features creative journal spreads. Again, copy them or paste them into your journal, or use them as inspiration for your own spreads. All of these drawings were created in a B5-size journal, roughly the same size as this book (7 by 9 inches). If you use a different size, you'll need to adjust accordingly. Because of the vagaries in printing, and differences among manufacturers, if you use a dotted journal you may need to adjust some of the lines so that they match up to the dots on your book.

Let's get started!

Keeping a Journal

We have talked about the benefits of doodling, so now let's talk about the second portion of this book: journaling. I have always kept a bullet journal, which I also use as an art journal for expressing my creativity. I find that using dotted or gridded pages help me create lettering that is tidy and attractive. I recommend a journal with fairly thick pages, because I like to use watercolor and markers (I prefer 160gsm paper—anything less than 120gsm might cause the colors to bleed through the page).

There are many benefits to keeping a bullet journal, and often people find that it helps with mental health, just as doodling does. Being able to organize your life in a way that is meaningful to you, having reassurance that tasks and appointments will be remembered, and being able to express yourself creatively all help with anxiety and stress. Your journal can be as minimalist or as complex as you like (though I like mine colorful and expressive!). I hope in this book you will find ideas on making creative journal pages that help you stay on track, all while feeling inspired.

Set aside a little time each day for journaling or doodling. It is a valuable creative outlet, and your mental health will benefit from some moments of quiet reflection on what you have achieved and what your plans are for the future.

Tools and Materials

You don't need to go overboard with buying lots of supplies to doodle or keep a journal, although many of us get addicted to all the pretty things that are available! For journaling, you'll find you get the best results with good-quality paper and pens, but for doodling, anything you have available is fine. This is part of the reason doodling is such a perfect escape—it's affordable and accessible to all.

My favorite journal is B5 (roughly the same size as this book) with 160gsm paper, although some people prefer a smaller size for easier portability. At a minimum, you will want to have paper, a pencil, an eraser, a pencil sharpener, and a pen.

For pens, I like waterproof black pigment liners. The drawings in this book were made with a pigment liner with a 0.3 nib. I always draw with a pencil first, then go over it with the black pen. Then I erase the pencil marks.

There are other supplies that you might want to play with. The supplies I like to have near my desk are:

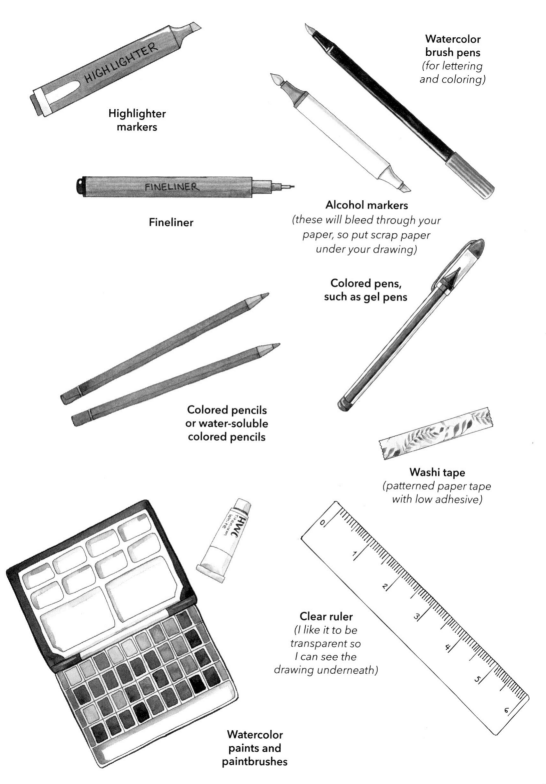

Highlighter markers

Fineliner

Watercolor brush pens
(for lettering and coloring)

Alcohol markers
(these will bleed through your paper, so put scrap paper under your drawing)

Colored pens, such as gel pens

Colored pencils or water-soluble colored pencils

Washi tape
(patterned paper tape with low adhesive)

Clear ruler
(I like it to be transparent so I can see the drawing underneath)

Watercolor paints and paintbrushes

Lines and Shapes

Doodling and journaling should be relaxing, so it helps if you feel confident with your tools. Try experimenting with some different pens and pencils to see which feel best in your hand. When I work in my journal, I draw with a pencil first, then go over it with pens, but there is something satisfying about bravely diving in with a pen and just seeing what happens.

Start by experimenting with lines:

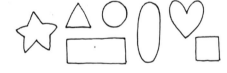

Fineliner pens, pigment liners, and many felt tip pens come in different thicknesses, from .005 (thinnest) to 0.8 (thickest). I usually prefer a 0.3 or 0.5 pen with waterproof ink so that I can add watercolor coloring if I wish. Begin by just drawing a straight line. It helps if you are using a journal with dotted or gridded pages, which act as guidelines. Try wavy lines, dots, loops, zigzags, and spirals.

Next, try some basic shapes:

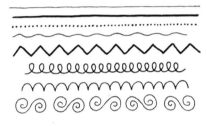

Most doodles begin with a shape. You'll see many cute animals in this book, and they nearly all start with some sort of circle or oval for the head. Practice drawing a page of flat, two-dimensional shapes. The more you practice, the more confident you will feel.

The next step is to add form. That is, to make an object look three-dimensional.

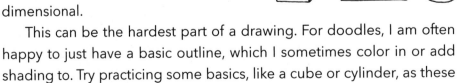

This can be the hardest part of a drawing. For doodles, I am often happy to just have a basic outline, which I sometimes color in or add shading to. Try practicing some basics, like a cube or cylinder, as these can be important building blocks for a drawing.

Combining Shapes to Make a Drawing

You can make quite detailed doodles just from combining basic shapes.

Watering Can

Start with a basic cylinder shape and add a circle for the handle. Next, add triangles and another half-circle, and the watering can begins to appear. One more triangle for the spout, and a little decoration, and you are done!

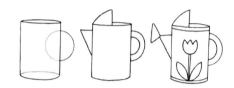

Light Bulb

Begin with a circle and a rectangle. Connect them with curved lines, and add a half-circle at the bottom. Add the filament, lines to the base, and the light bulb is done! Doodling is easy if you break it into shapes.

Alarm Clock

Start with a basic circle. Add an inner circle and two half-circles. Finally, add the small details with circles, triangles, and numbers.

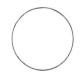

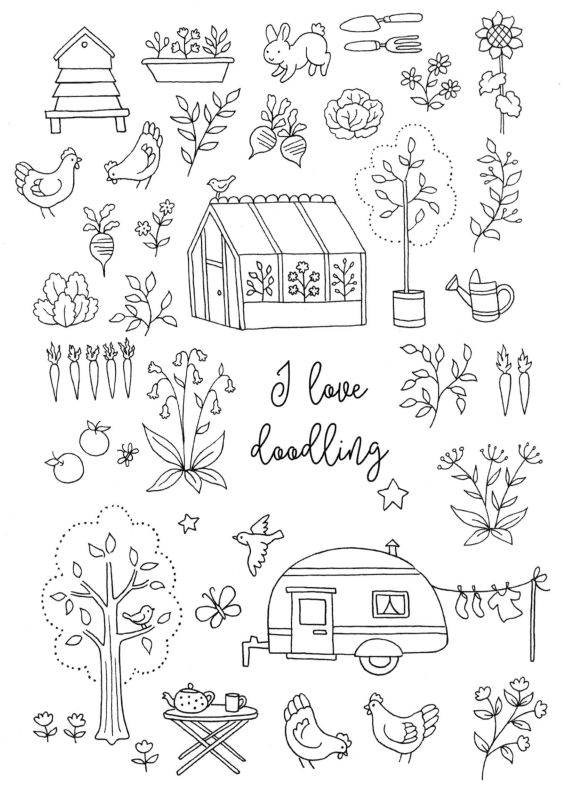

I love doodling

Section One:

Tutorials and Doodle Library

In this section you will find lots of doodle examples and tutorials to help you relax and explore your creativity. There are pages of doodles, divided by topic, to give you inspiration. Each of those pages has a companion page where I break some of the drawings into steps. There are generally four or five steps, and each step adds a little more detail until the drawing is complete.

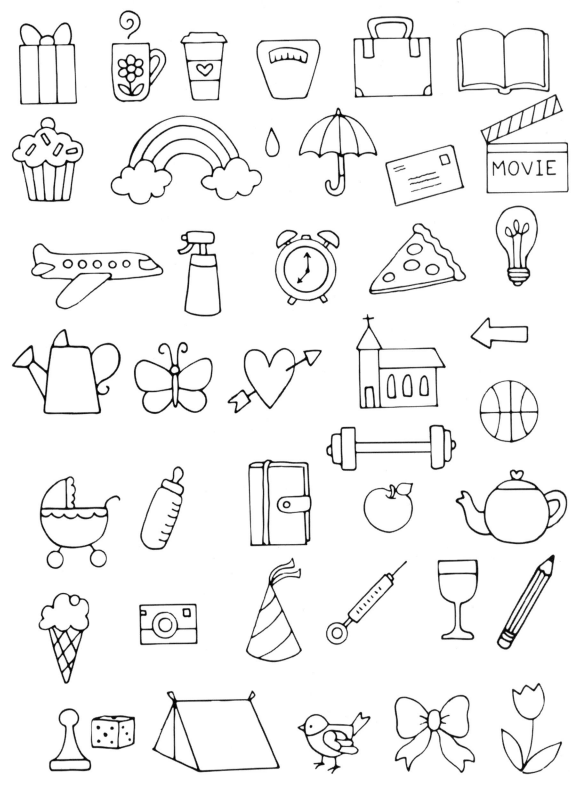

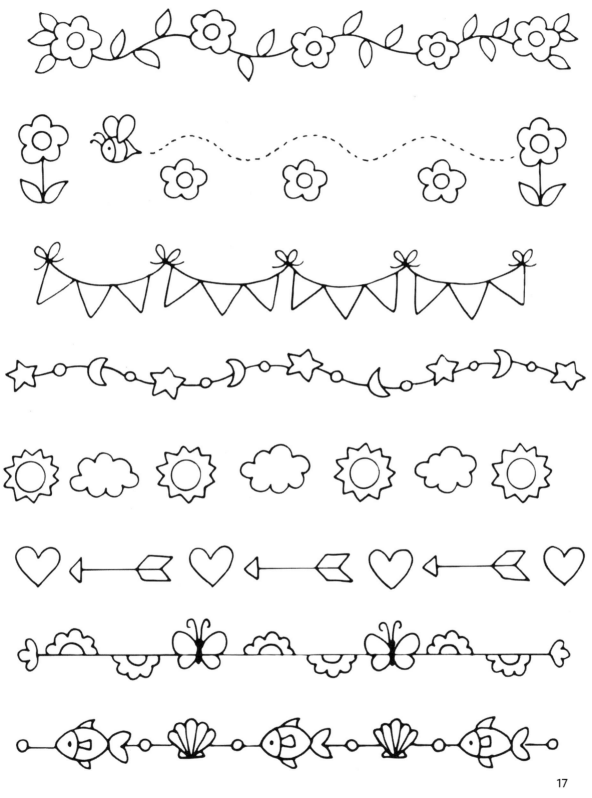

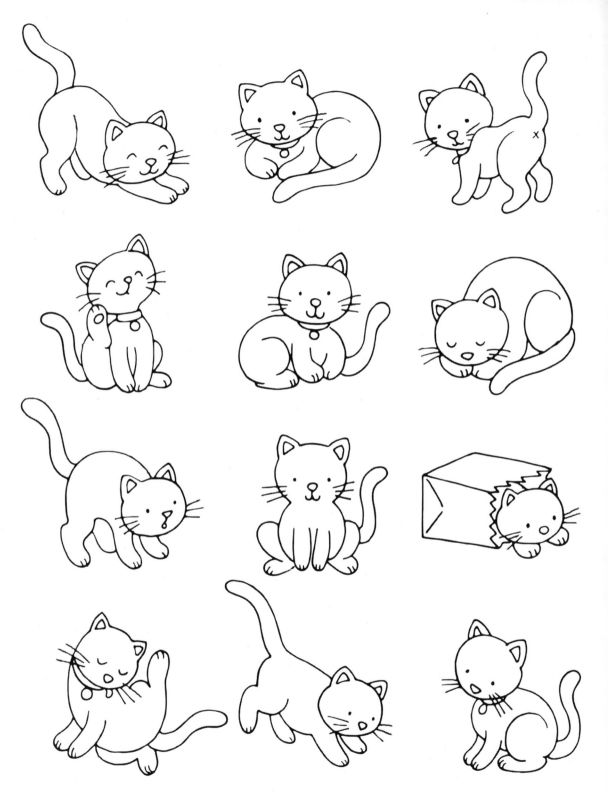

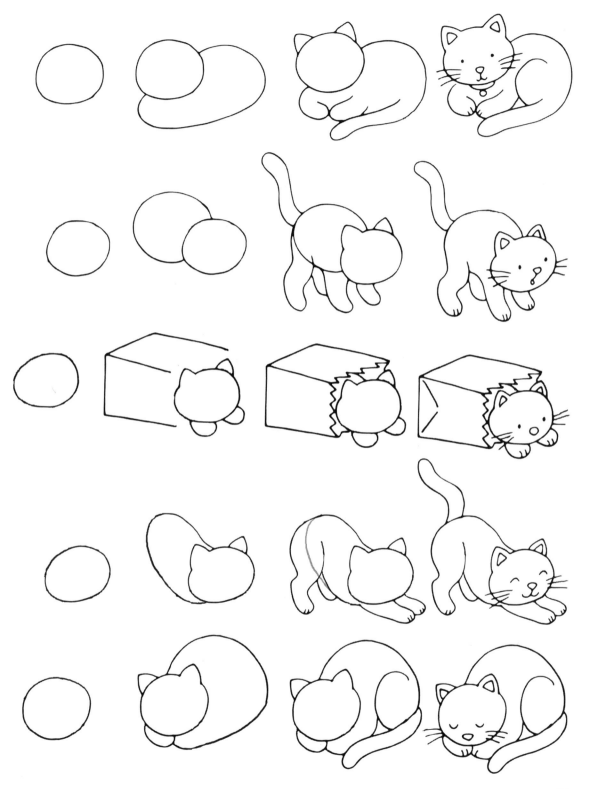

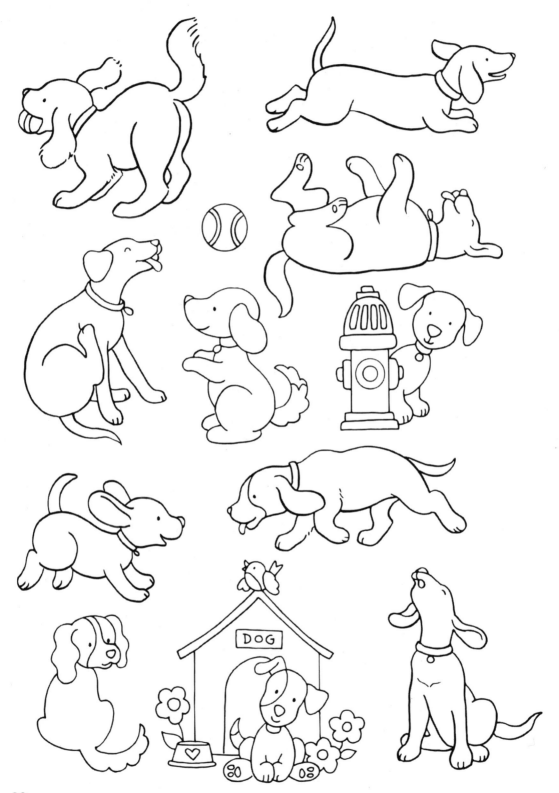

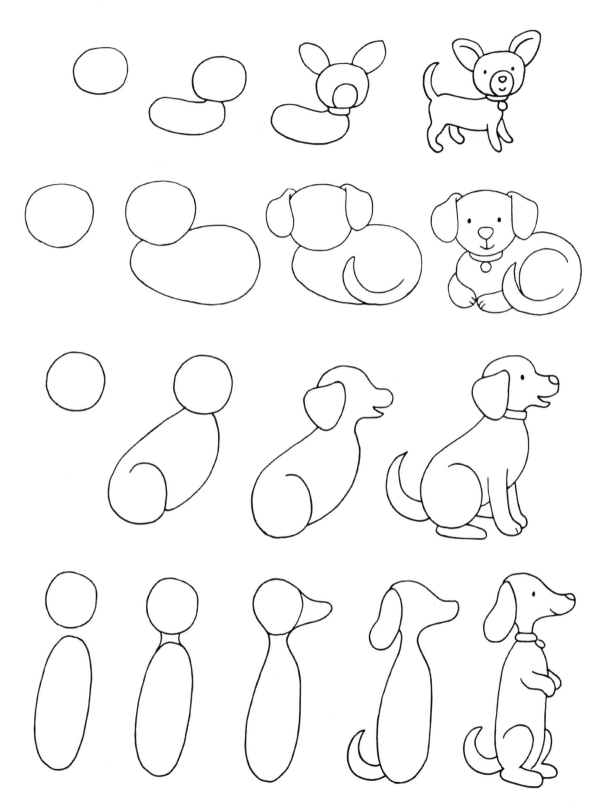

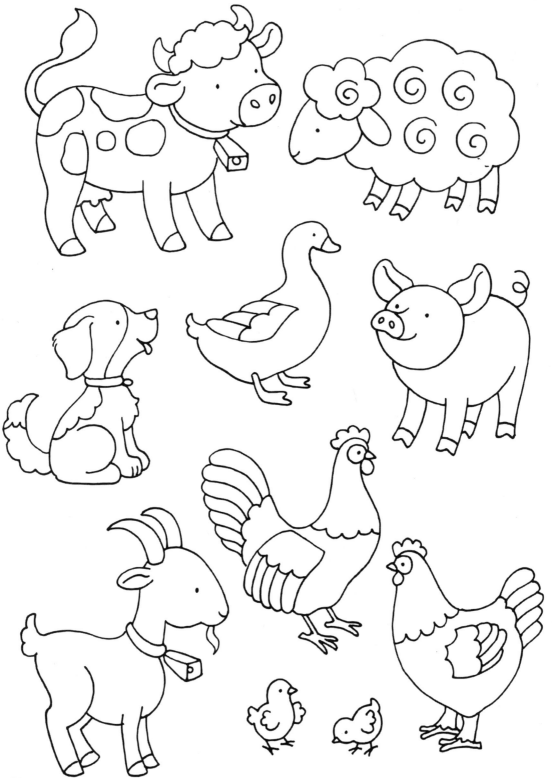

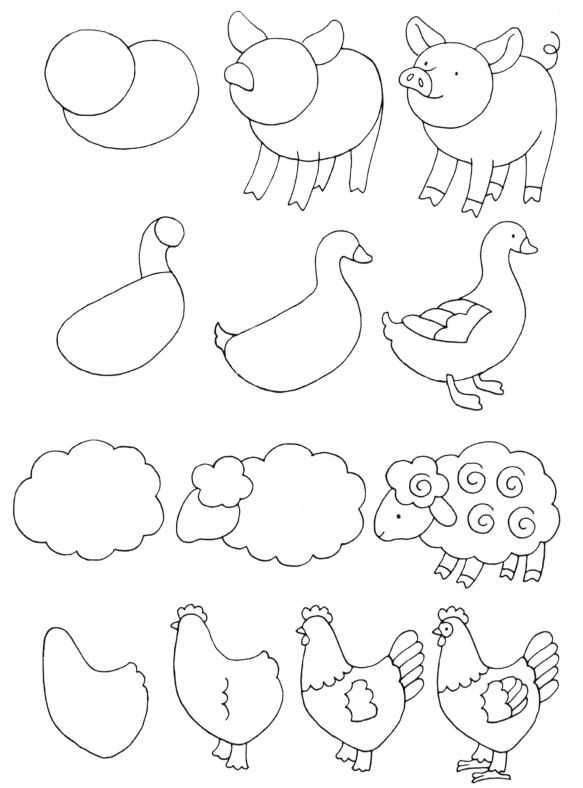

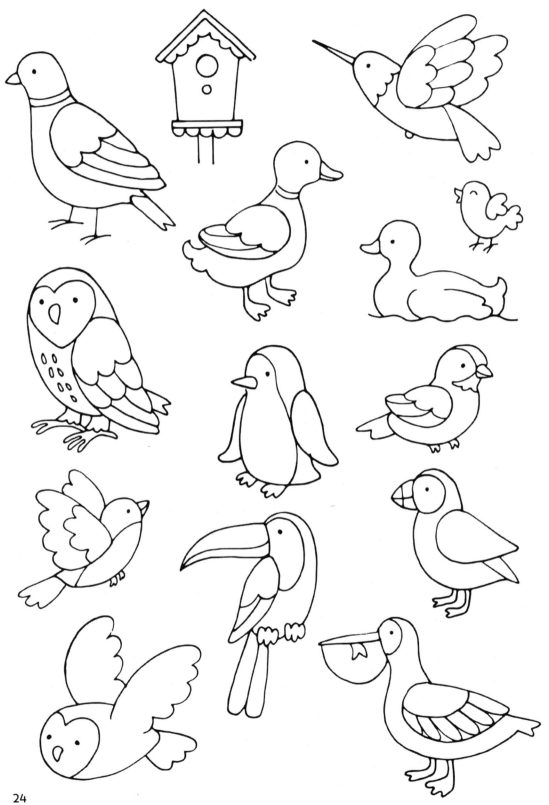

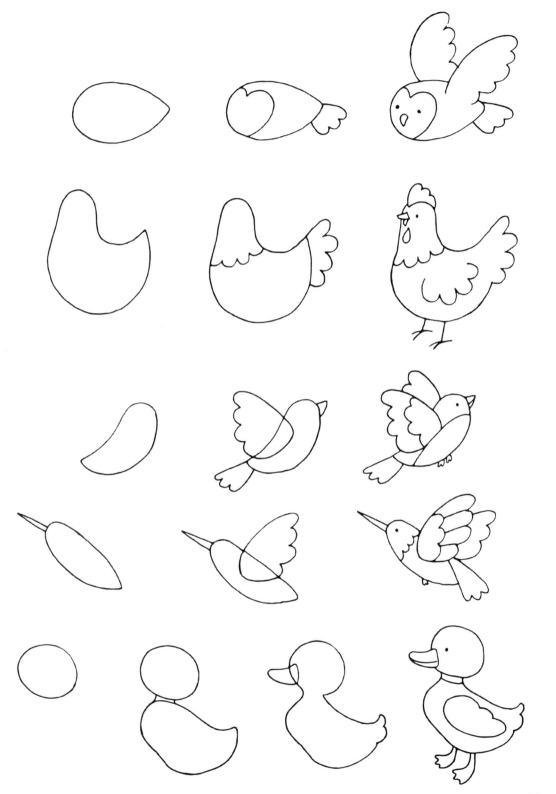

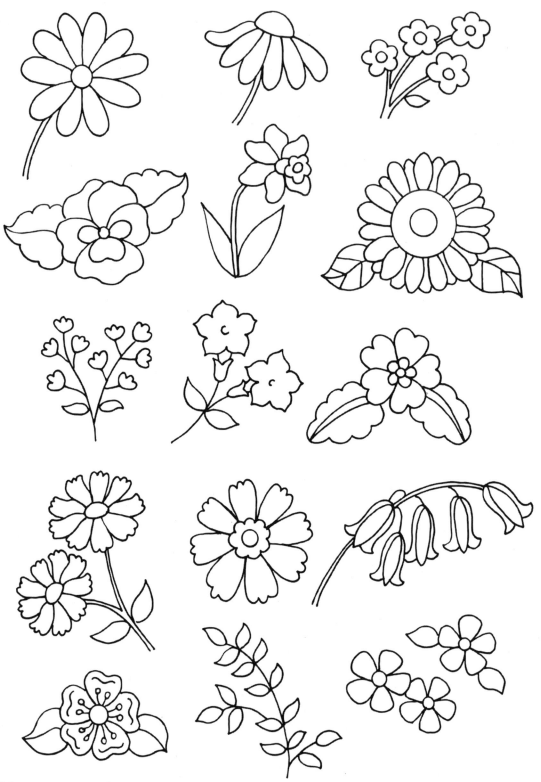

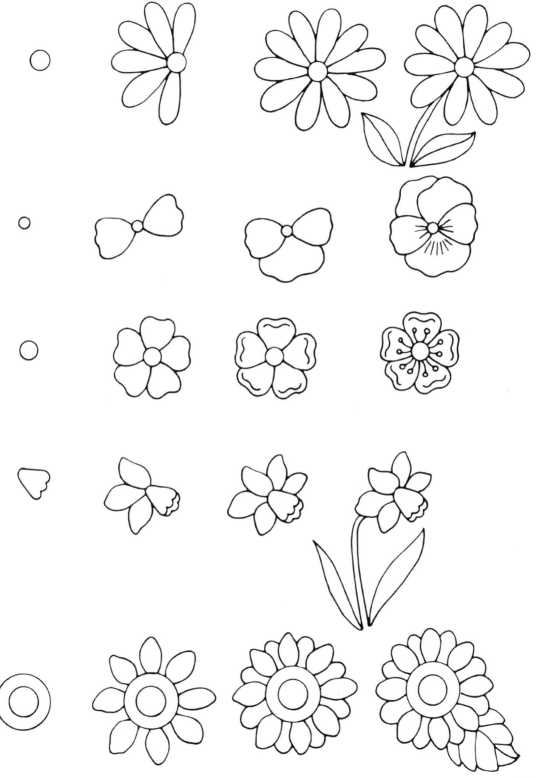

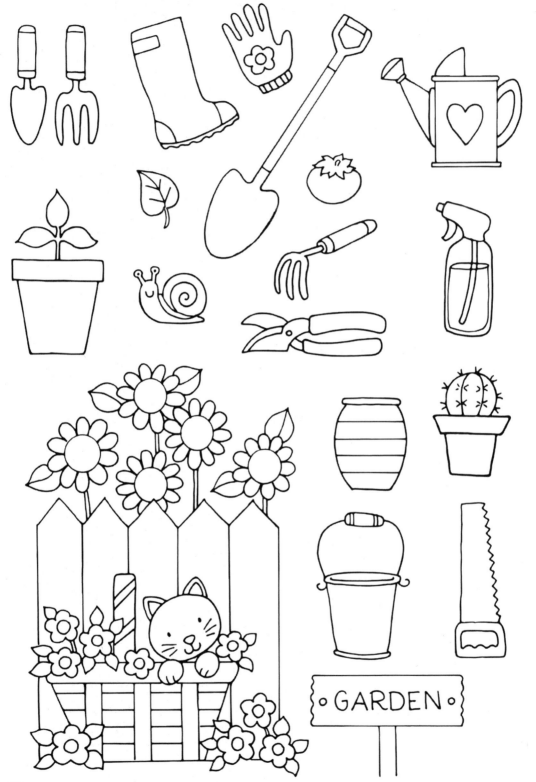

GARDEN

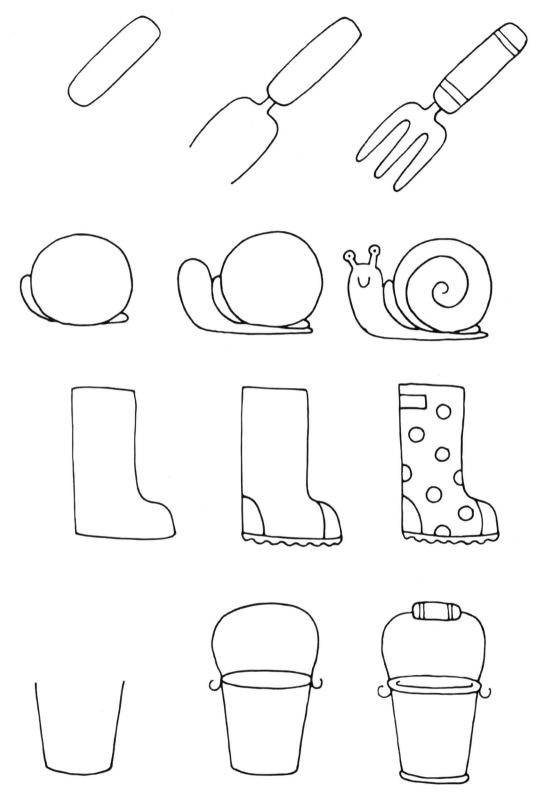

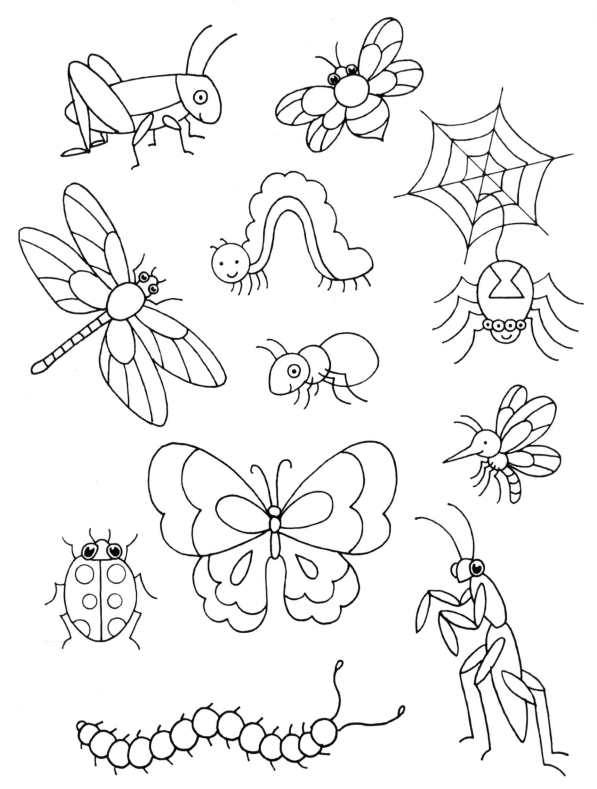

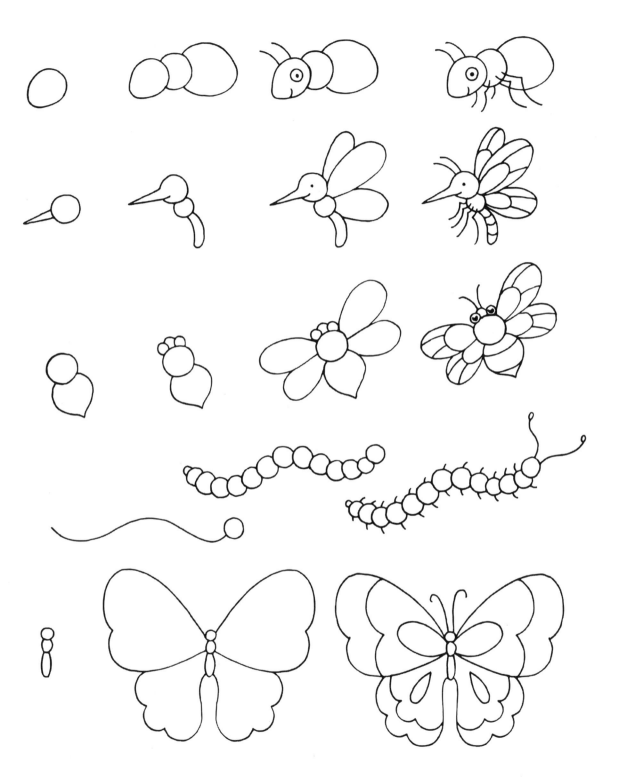

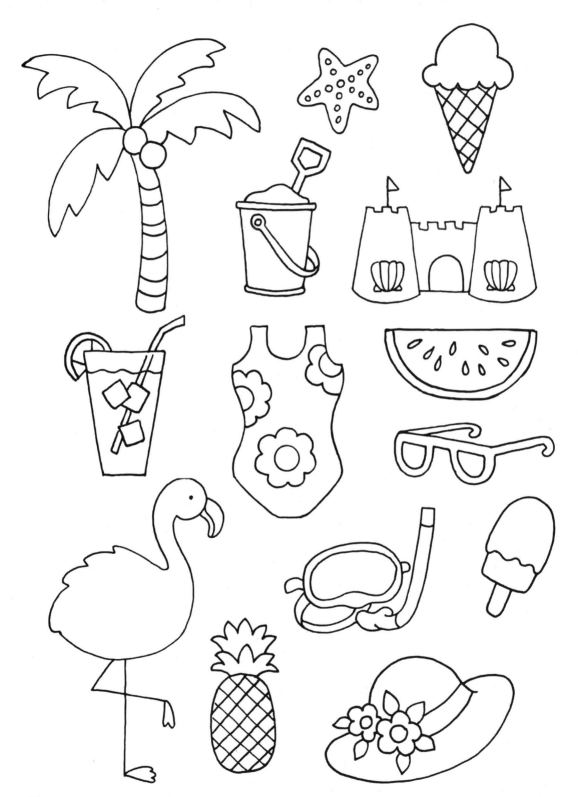

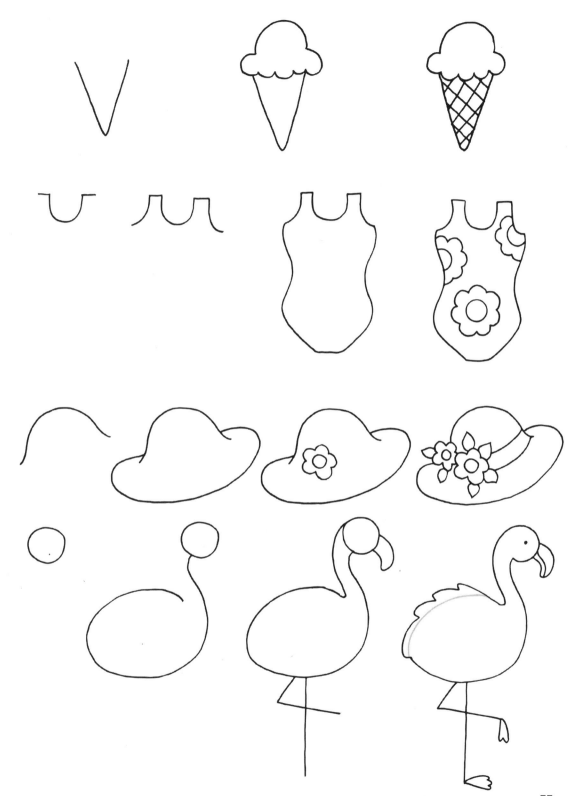

33

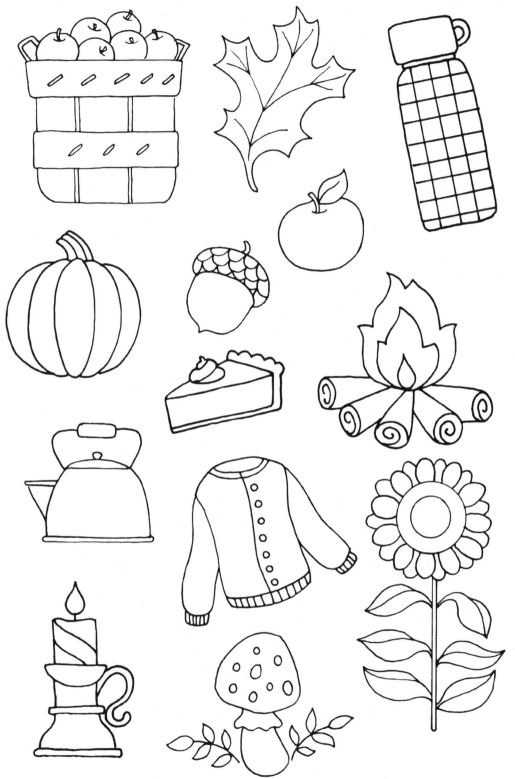

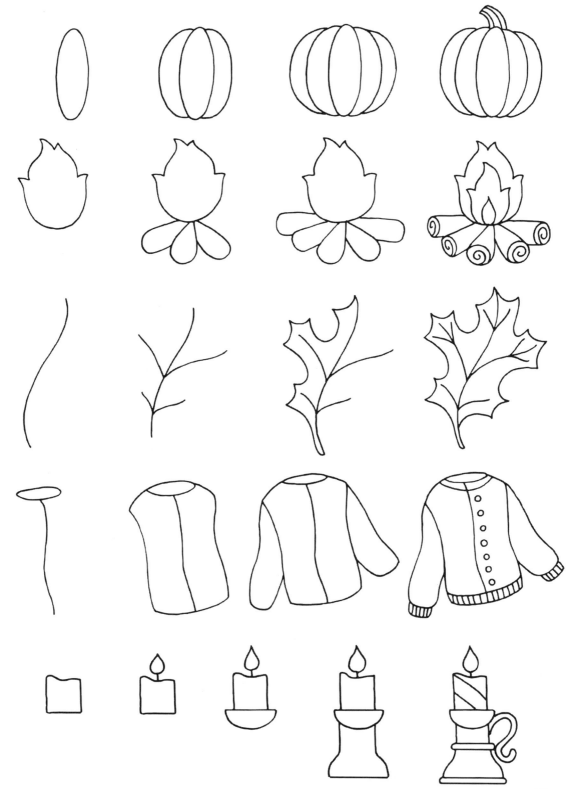

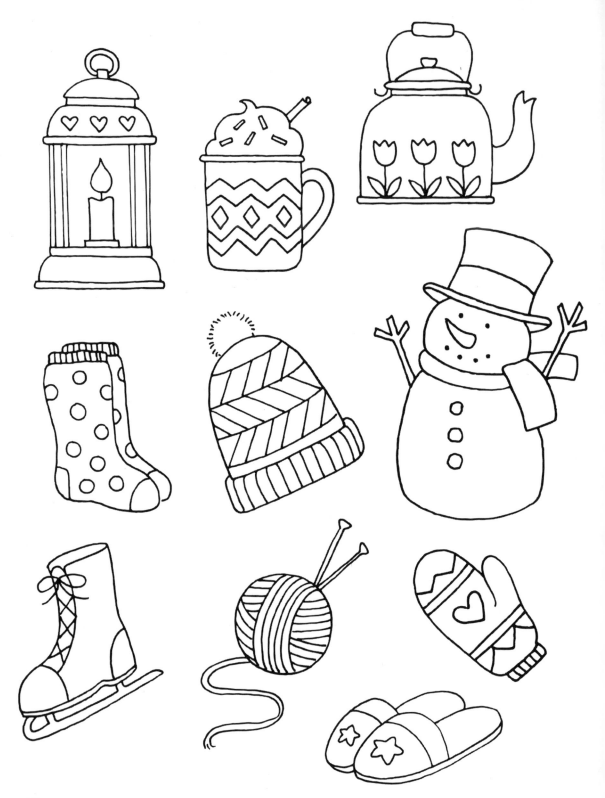

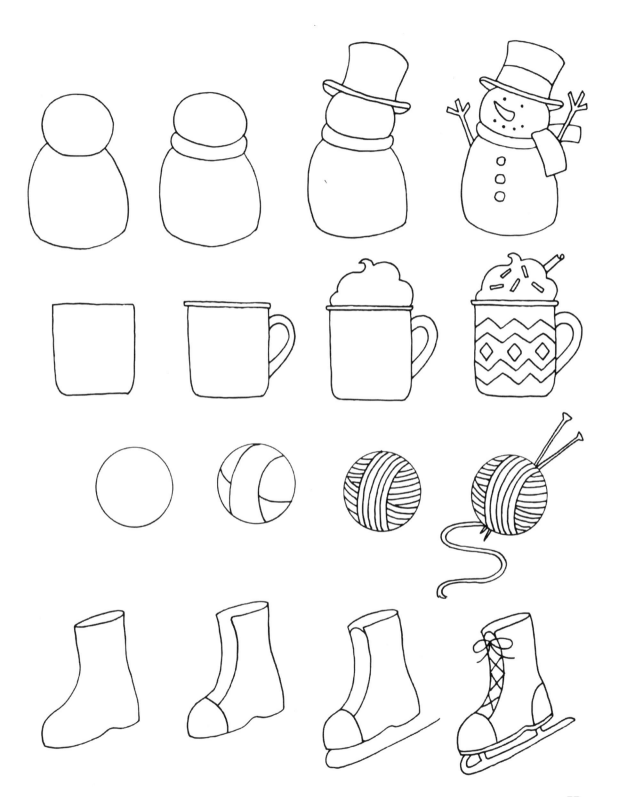

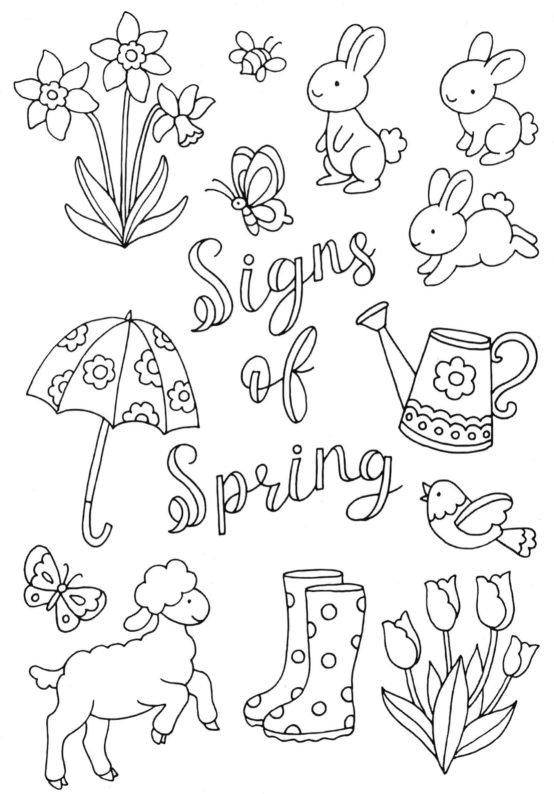

Signs of Spring

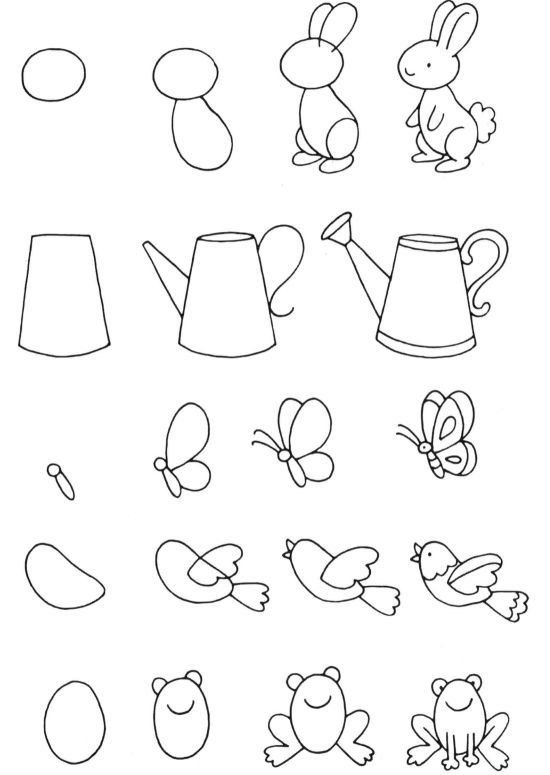

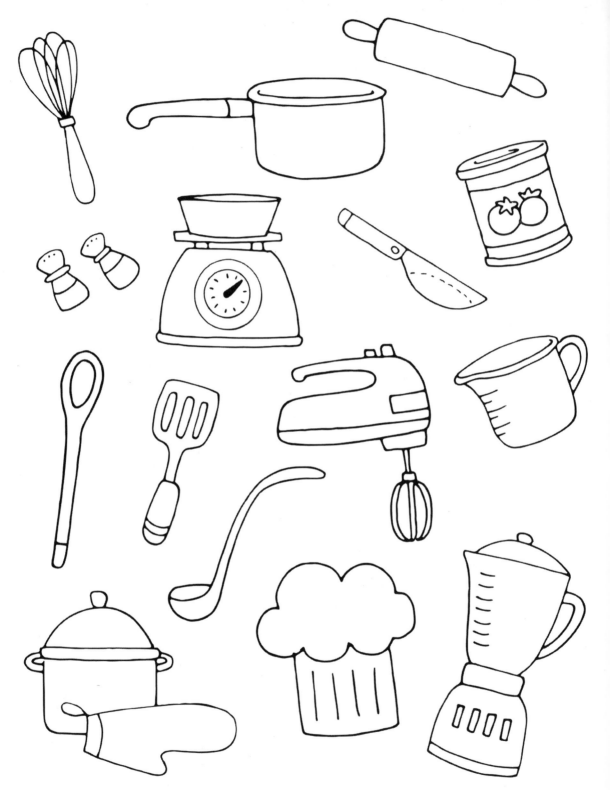

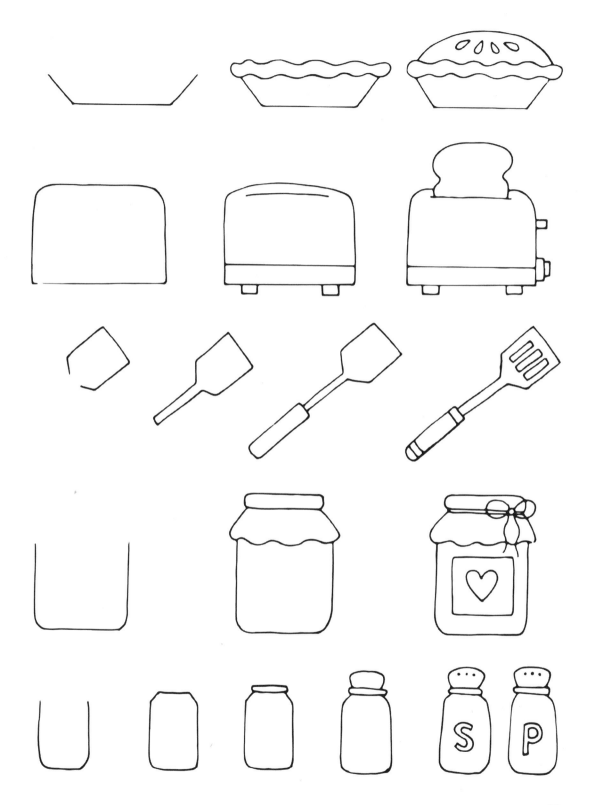

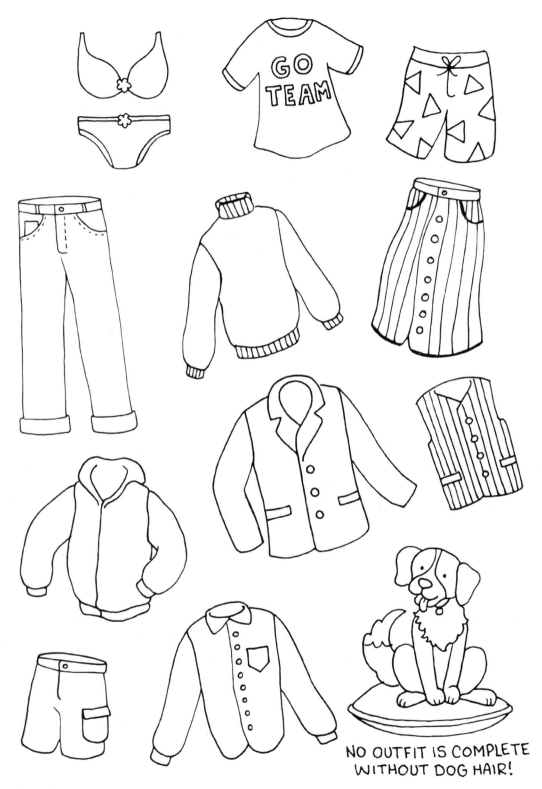

GO TEAM

NO OUTFIT IS COMPLETE
WITHOUT DOG HAIR!

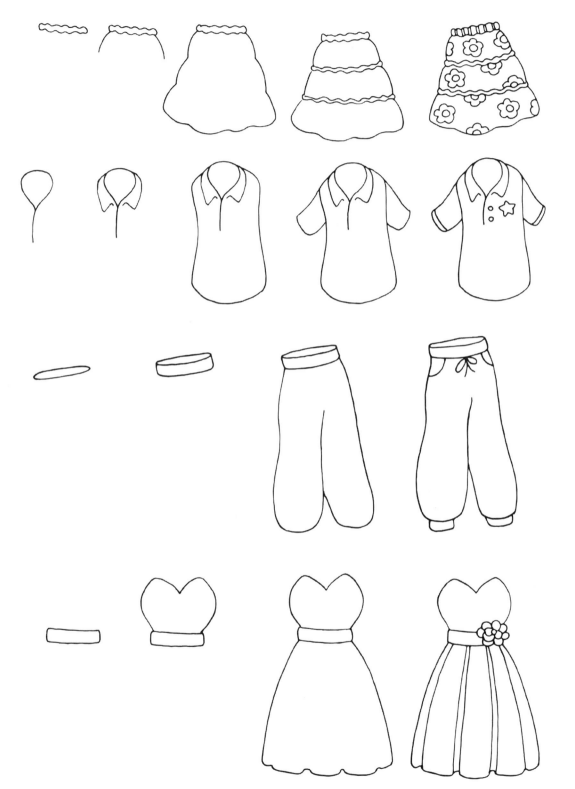

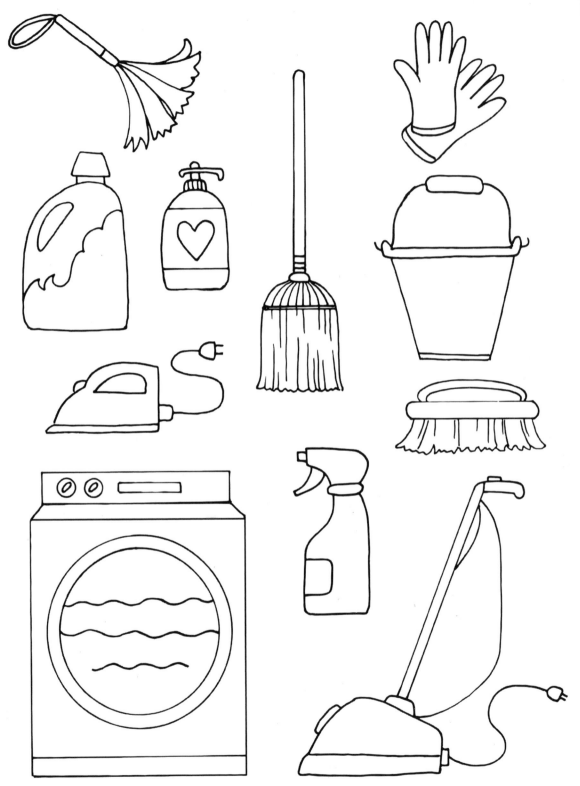

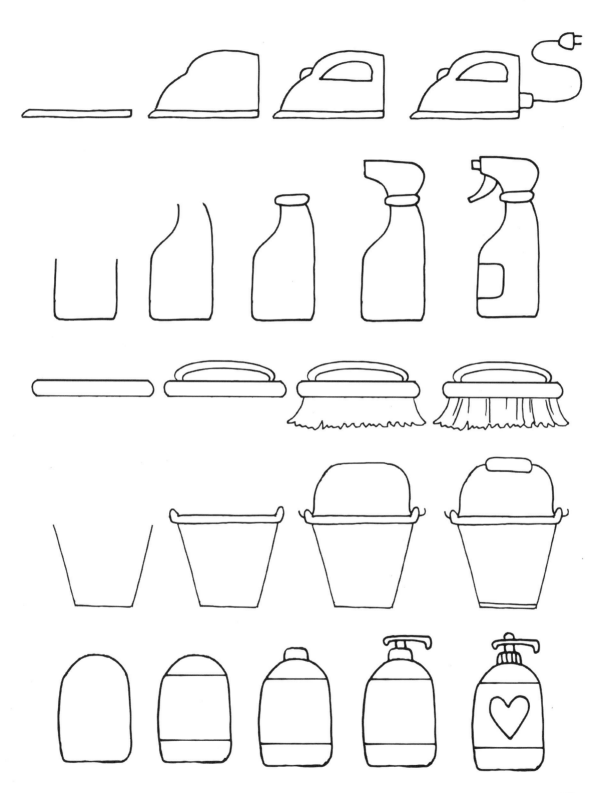

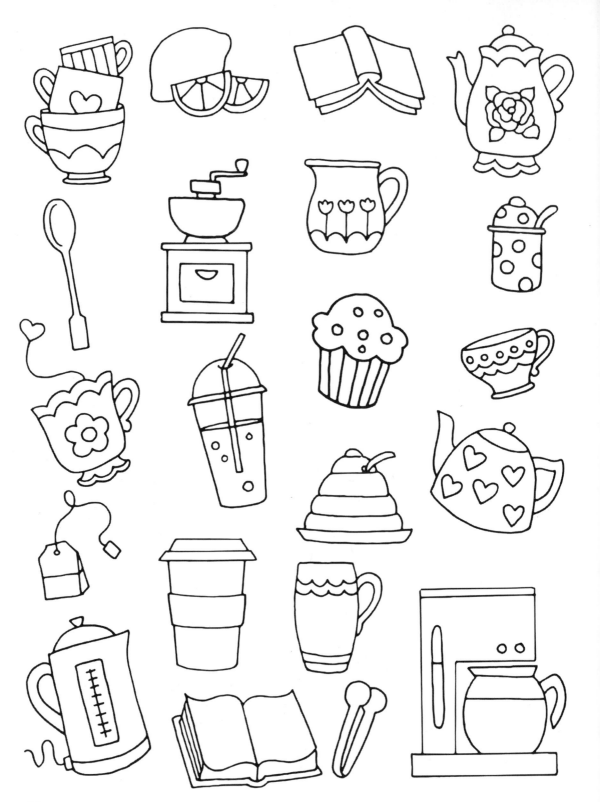

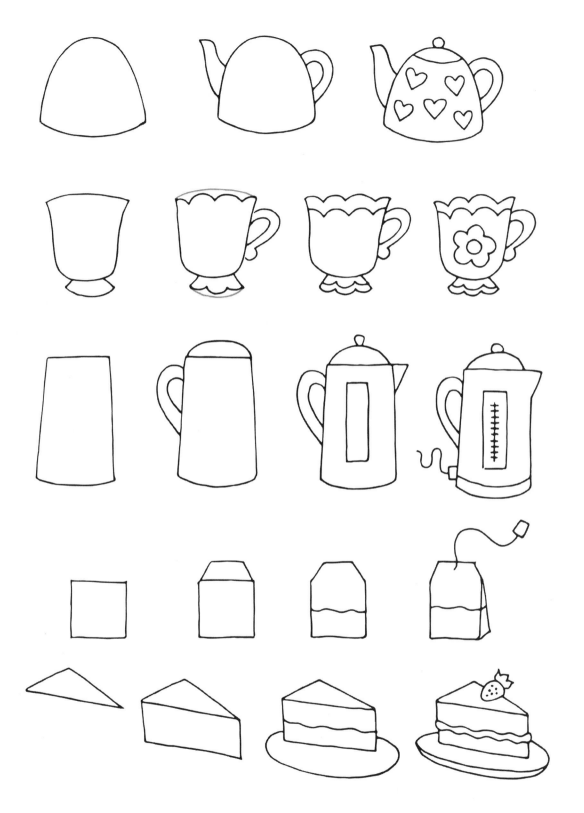

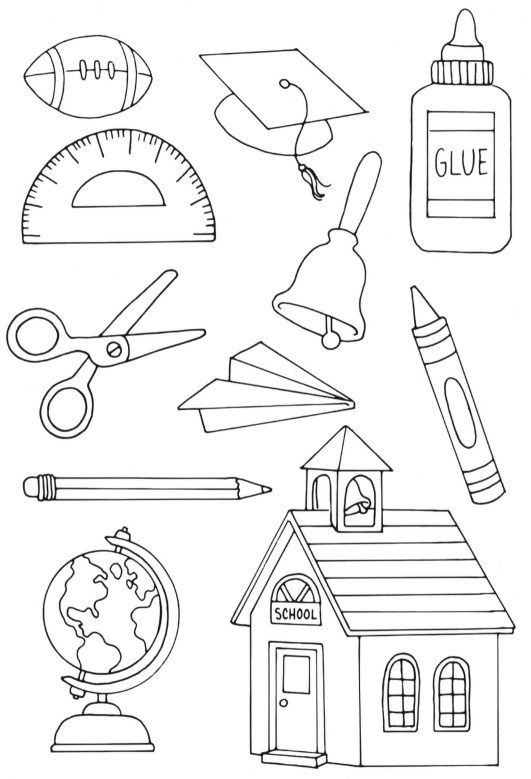

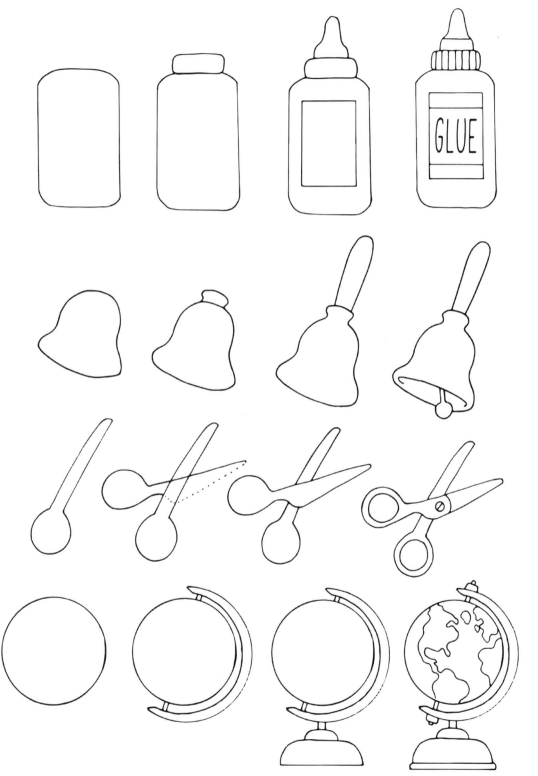

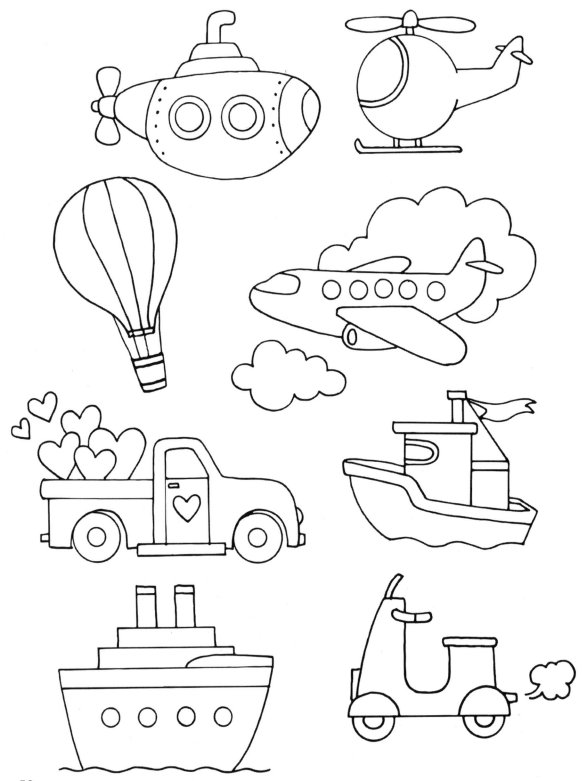

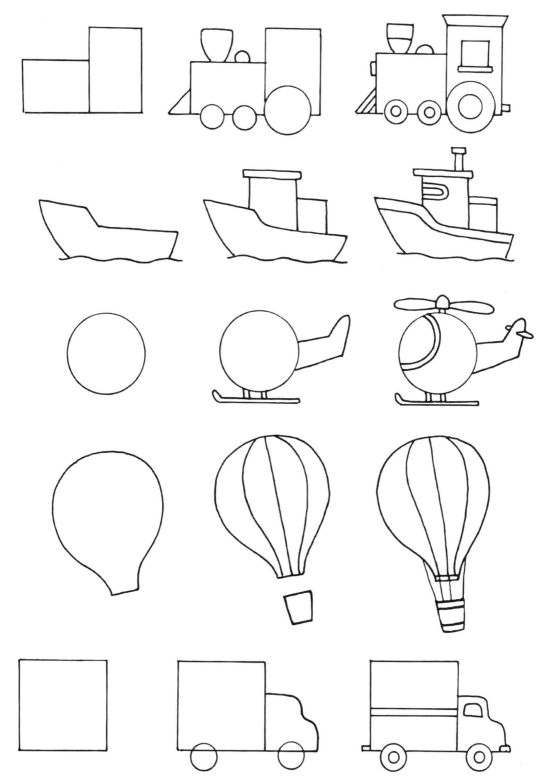

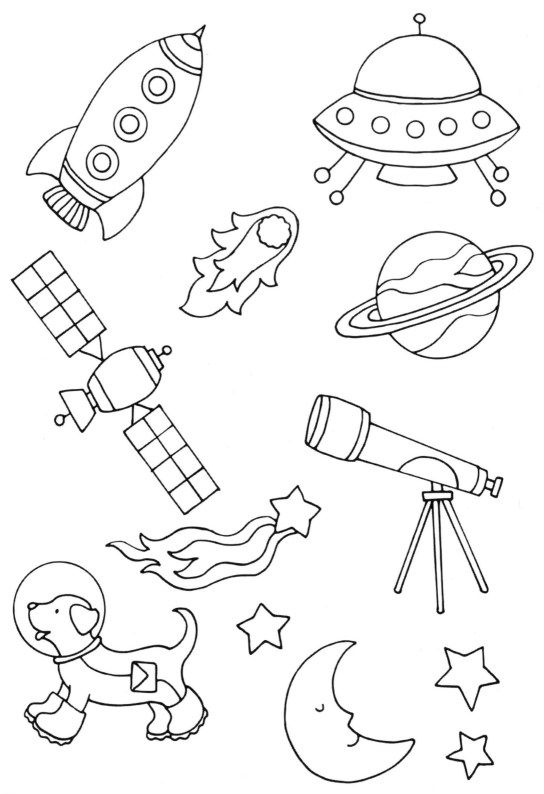

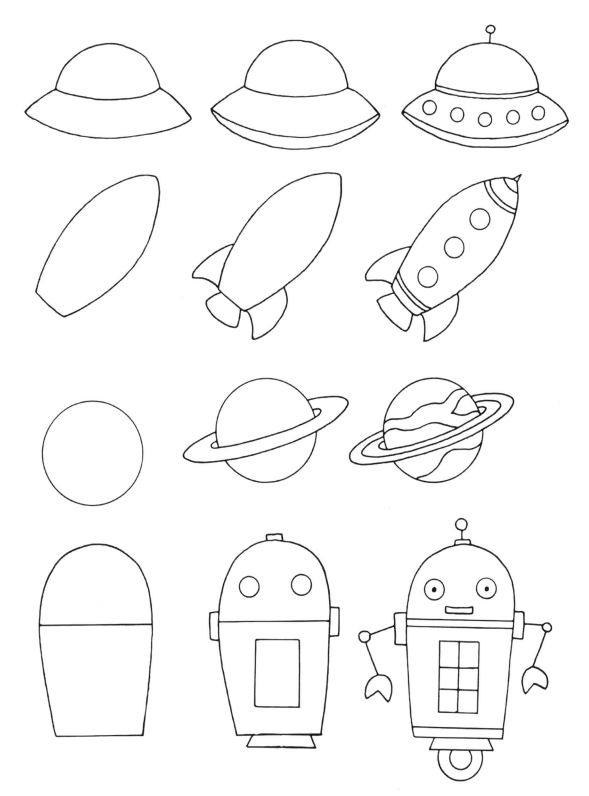

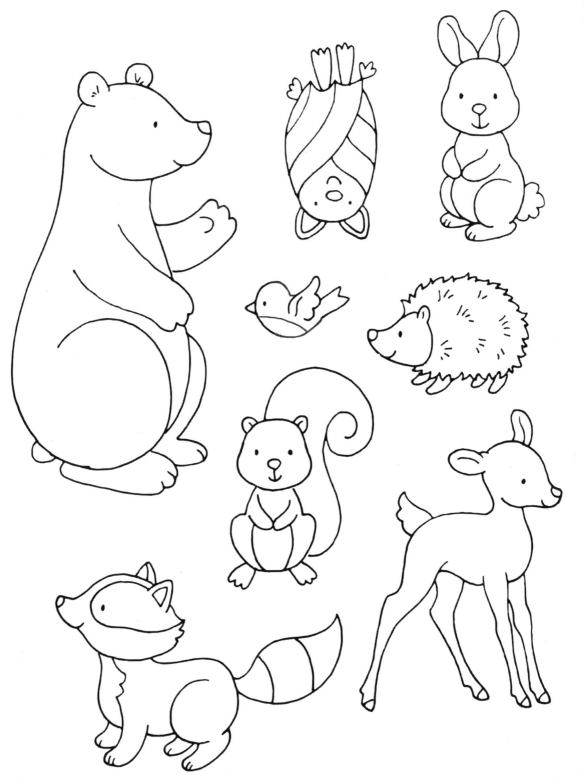

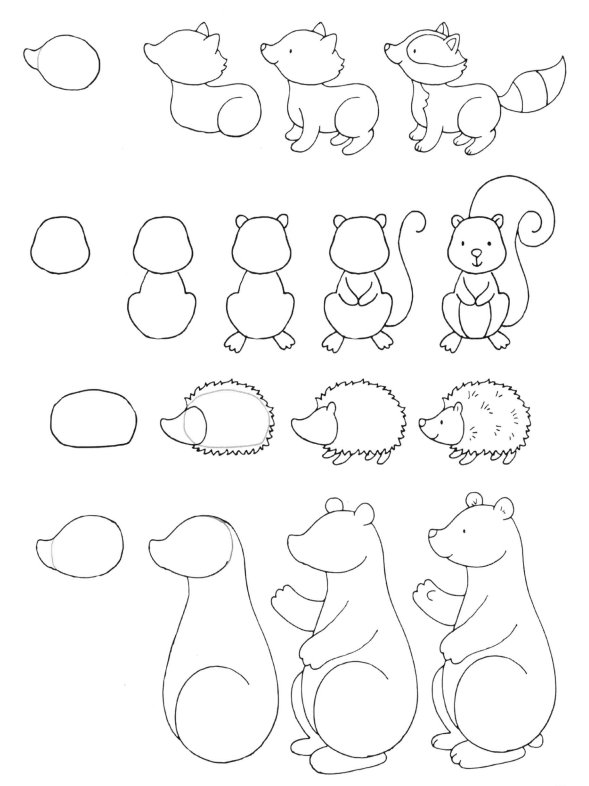

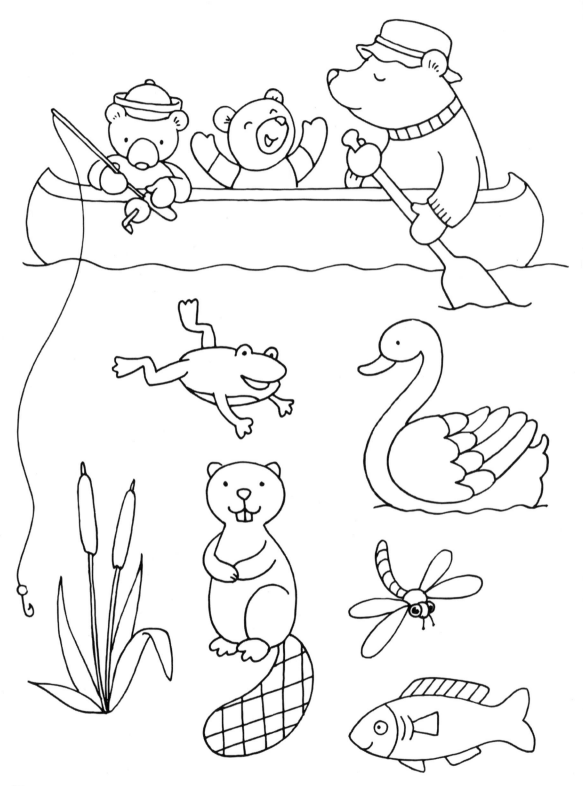

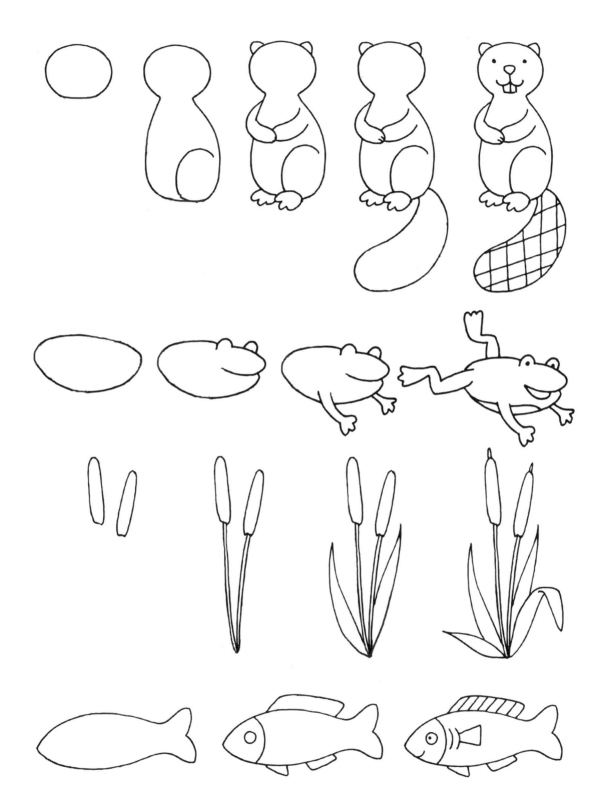

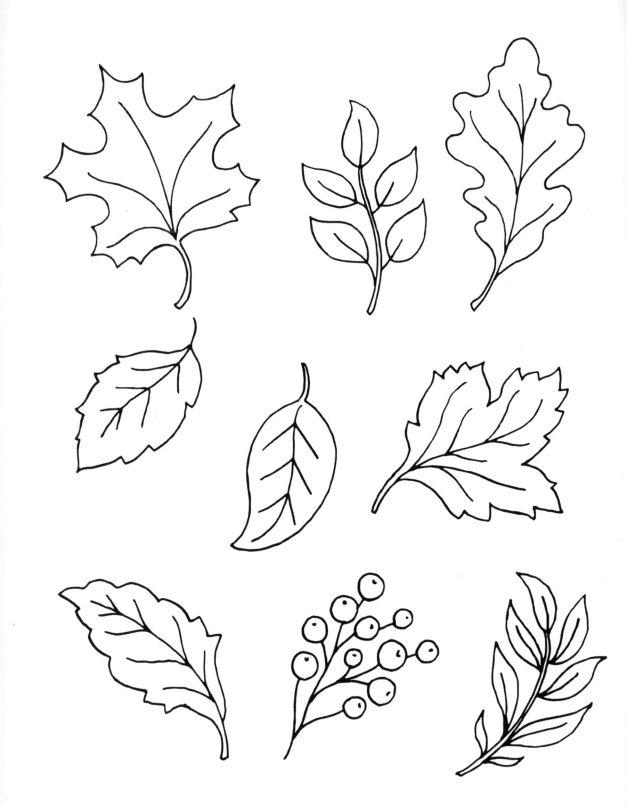

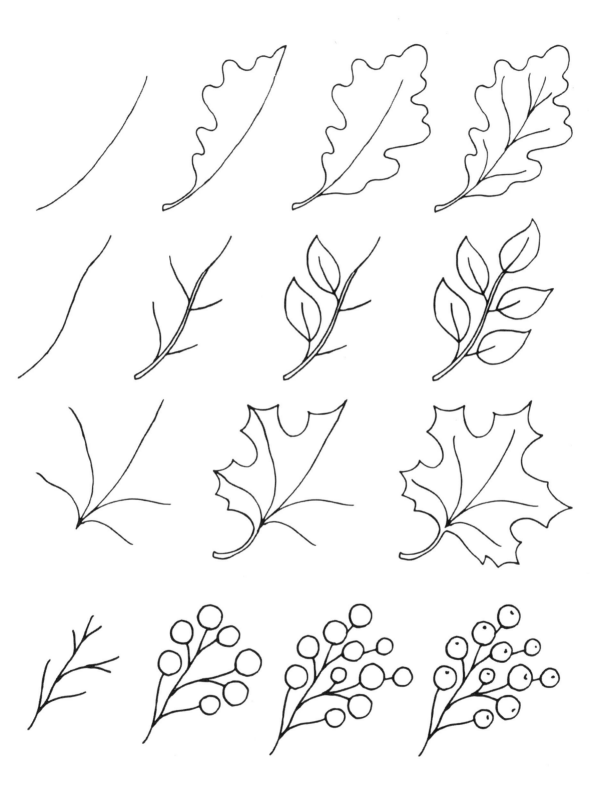

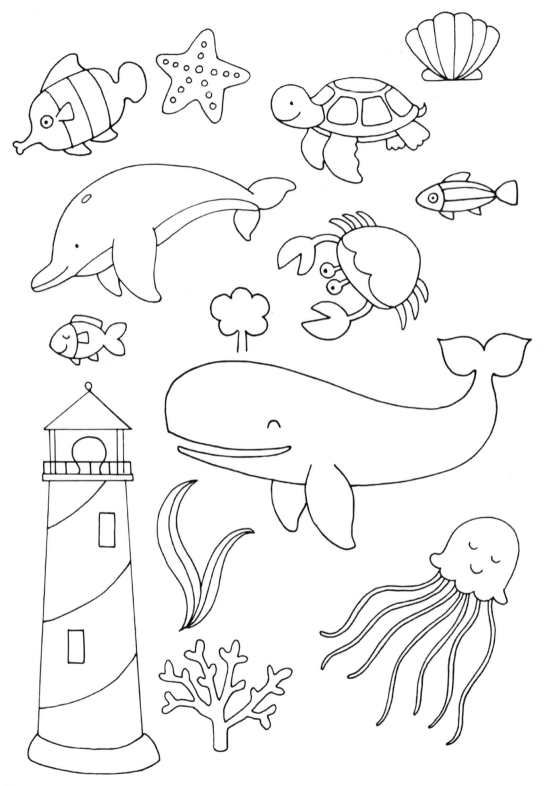

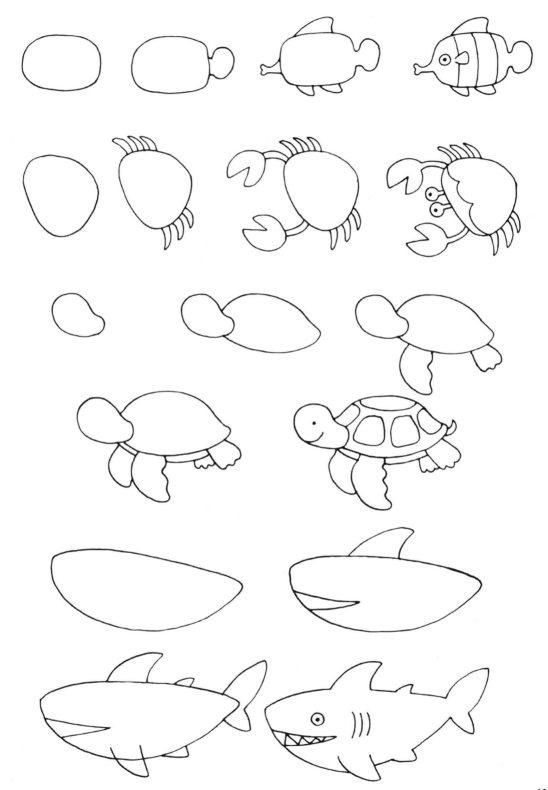

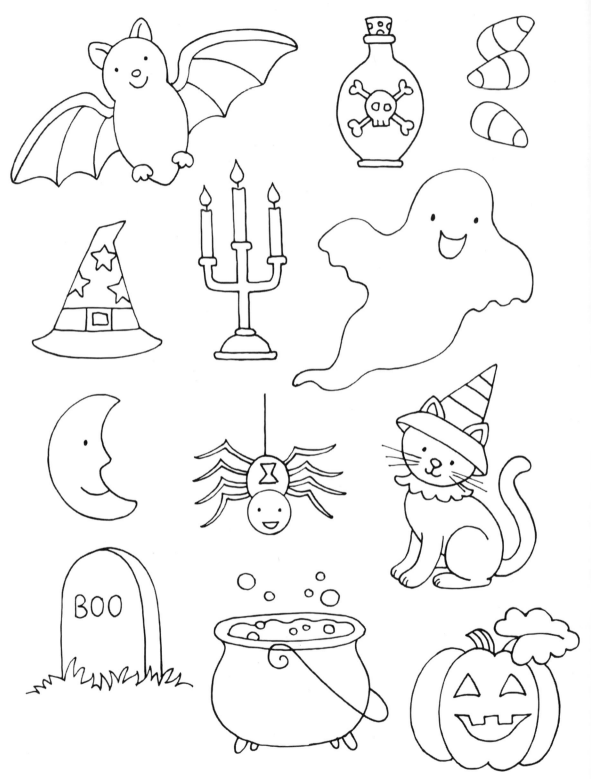

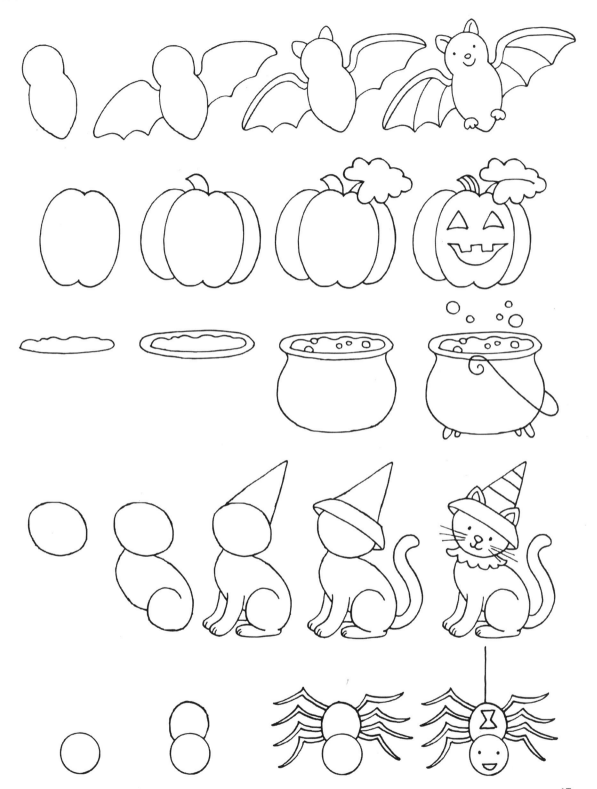

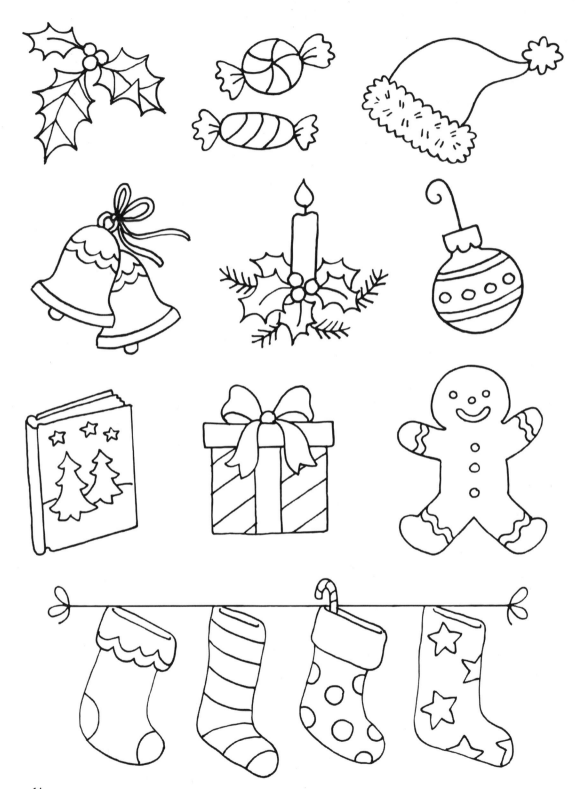

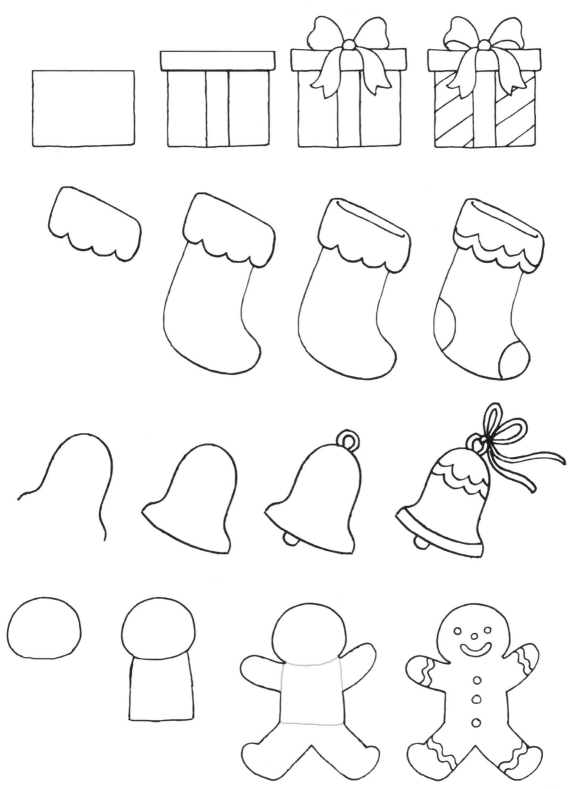

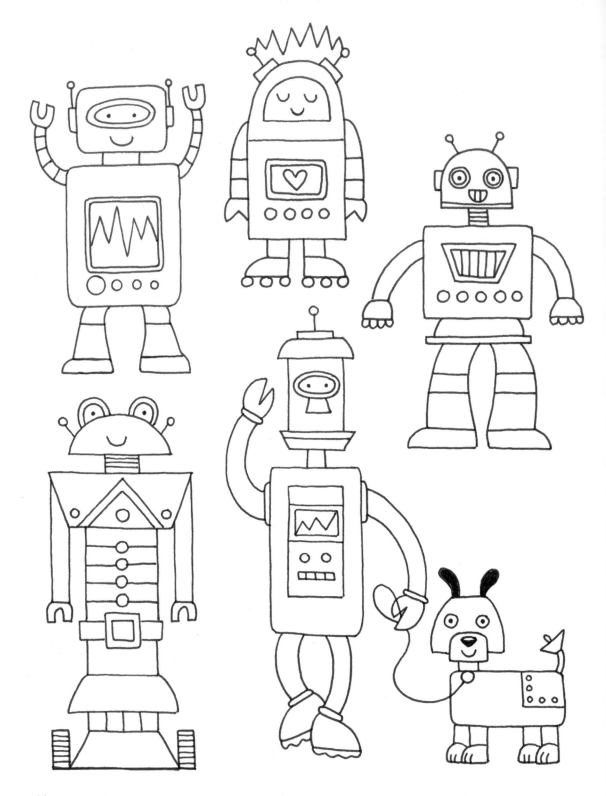

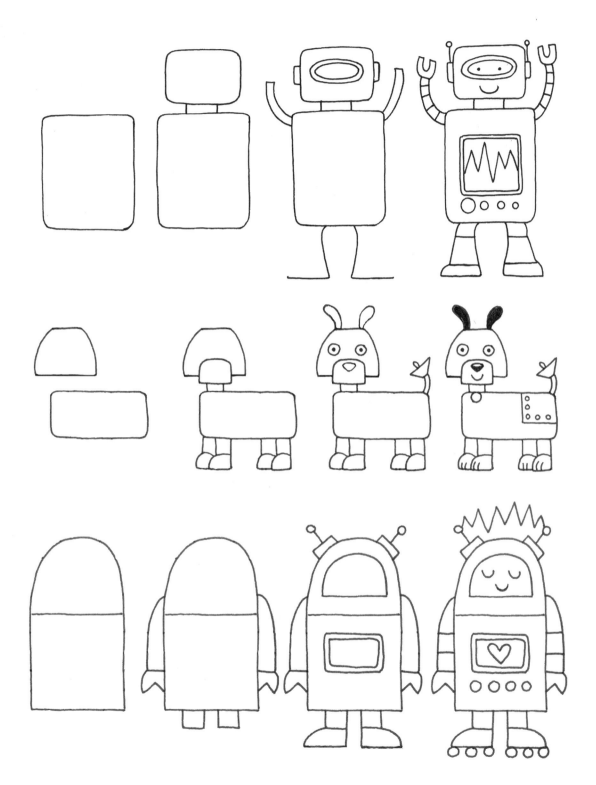

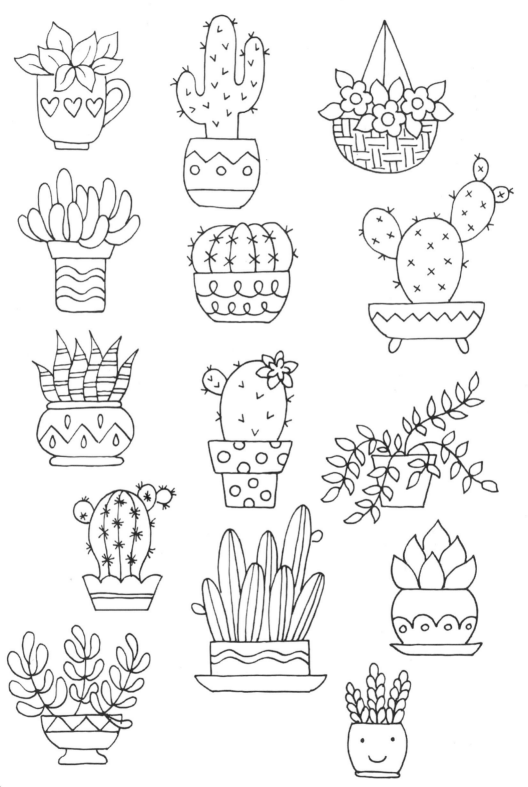

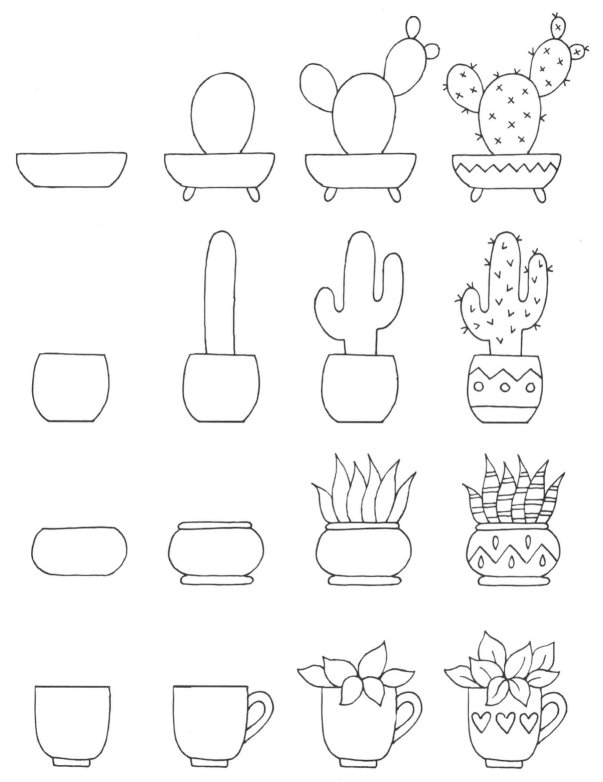

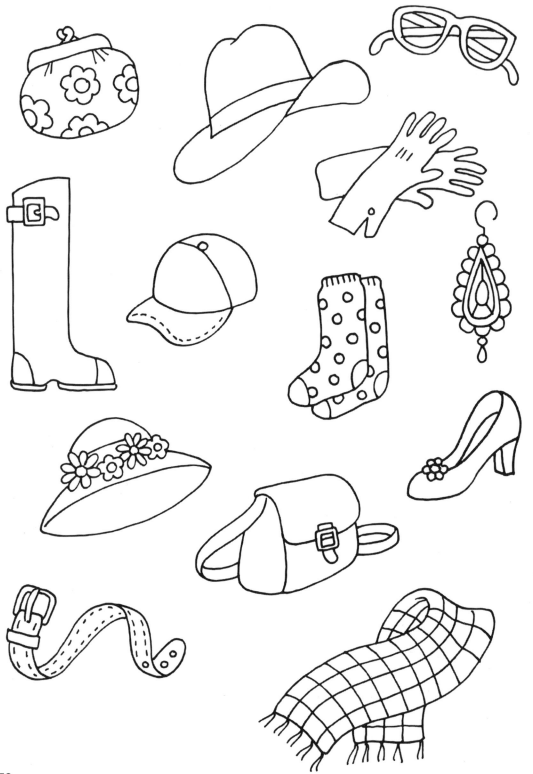

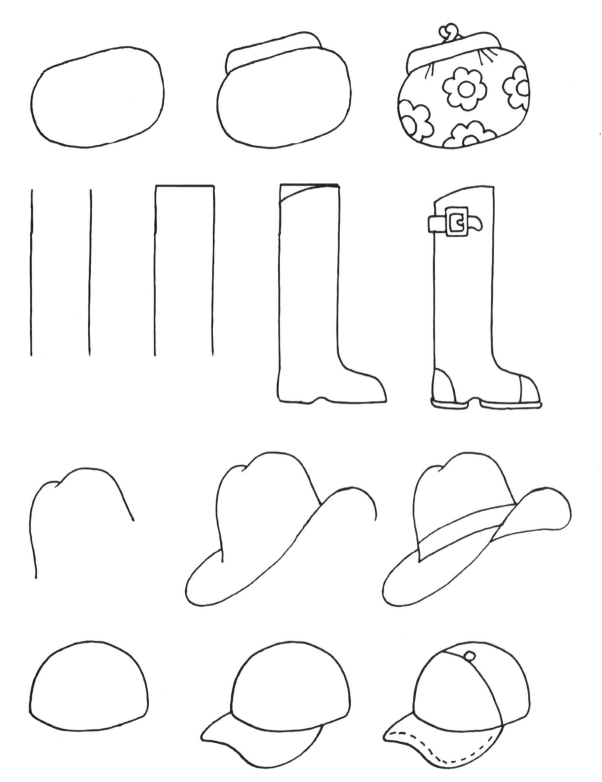

What's the Weather?

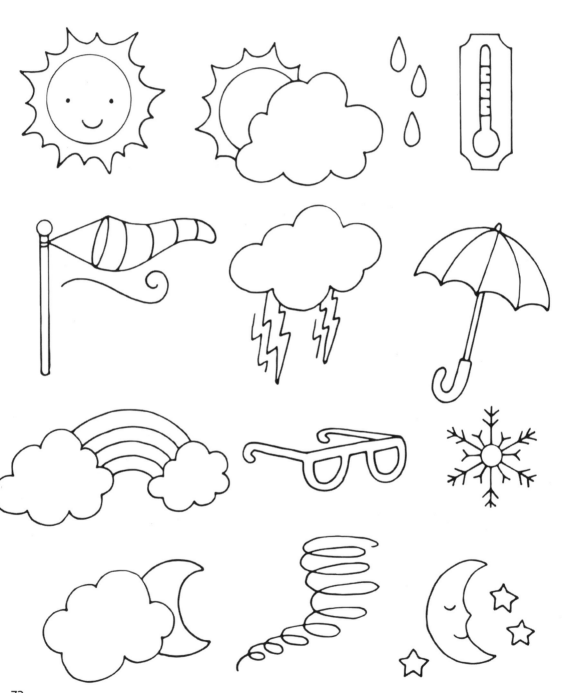

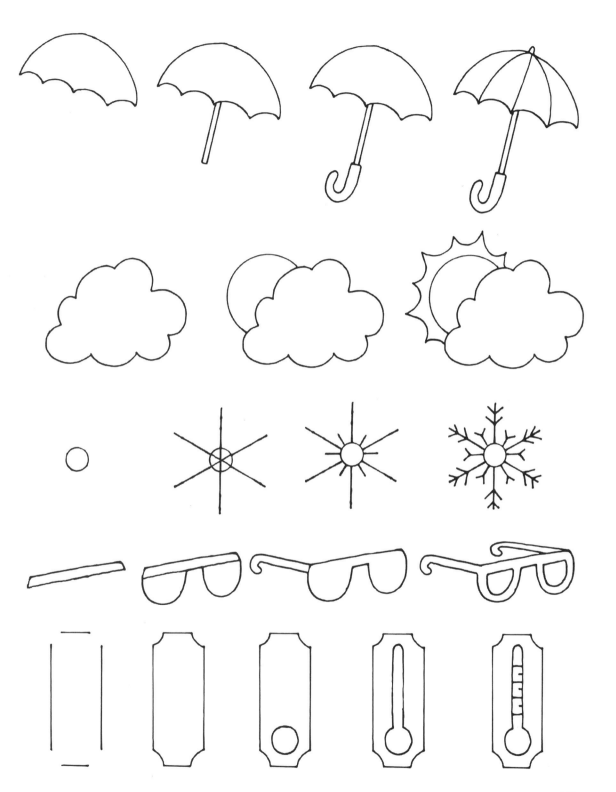

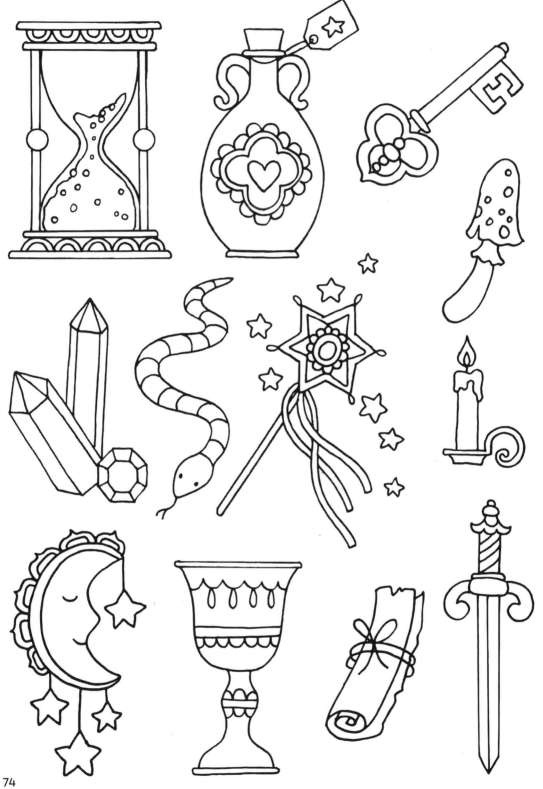

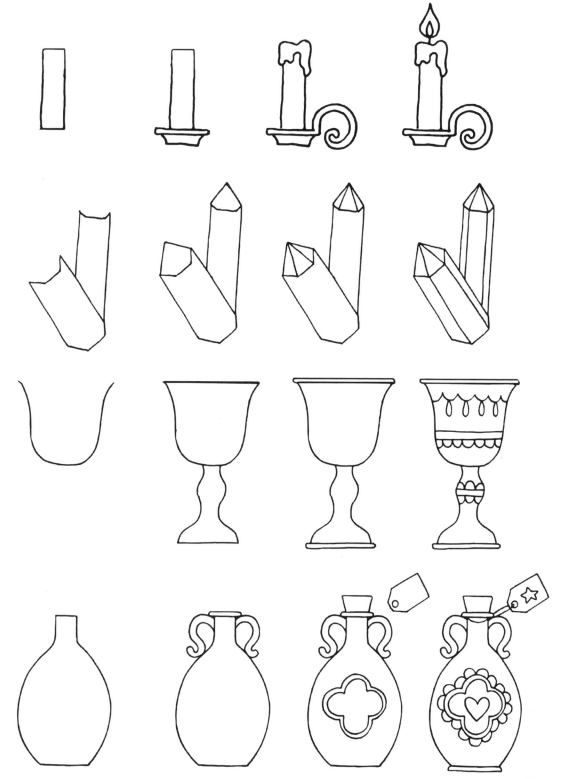

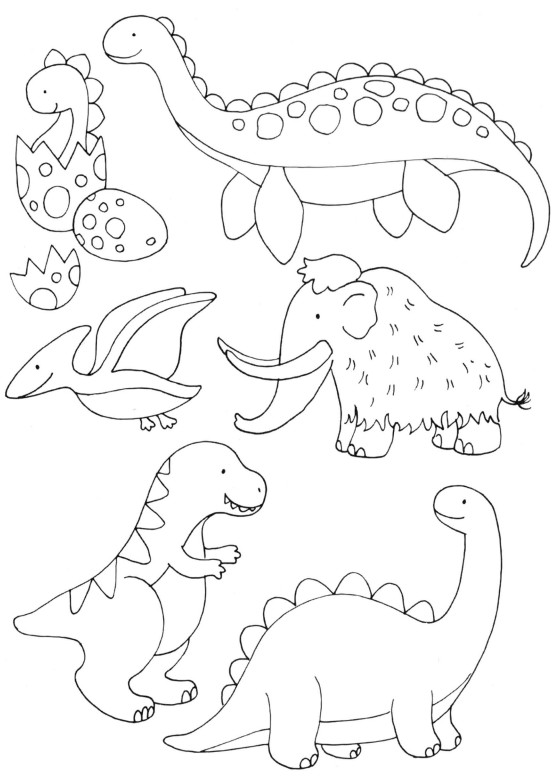

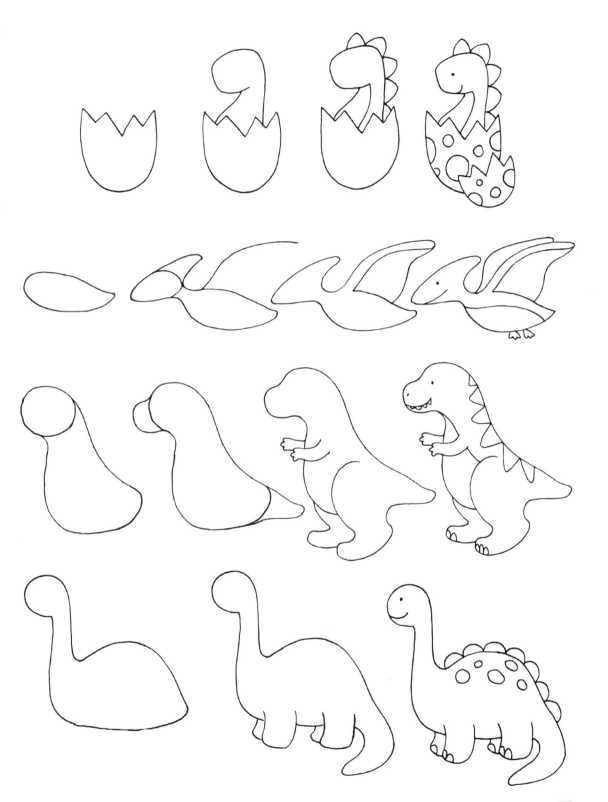

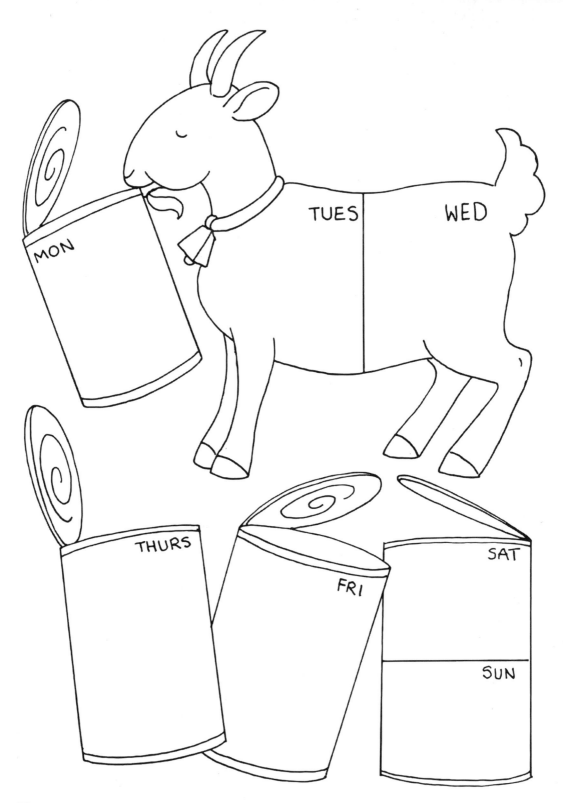

Section Two:

Journal Spreads

I find that I am much more engaged with my journal when I add color and creativity to my pages, so this section is dedicated to ideas that will help you spruce up your entries. As you'll see in the pages to come, you can copy these doodles, trace them, or cut them out and paste them in! And just maybe, these ideas will spark ideas of your own.

I've included a couple of pages titled "mood trackers"—color in one section per day, depending on your mood at the time. At the beginning of the month, choose colors to go into the key: for example, blue for sad, and yellow for happy. I've found that this exercise is not only soothing but helpful in getting in touch with my day-to-day frame of mind—a wonderful practice for those looking to reconnect with their emotions and sense of self.

Try and set some time aside each day for journaling or other forms of creativity. Make it part of your routine, and you will find that it is a great way of nurturing yourself and combating stress.

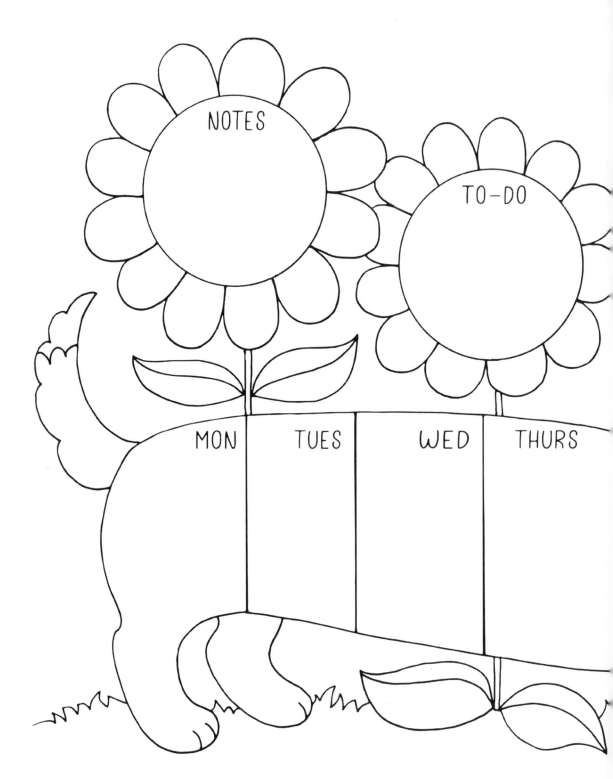

NOTES

TO-DO

MON TUES WED THURS

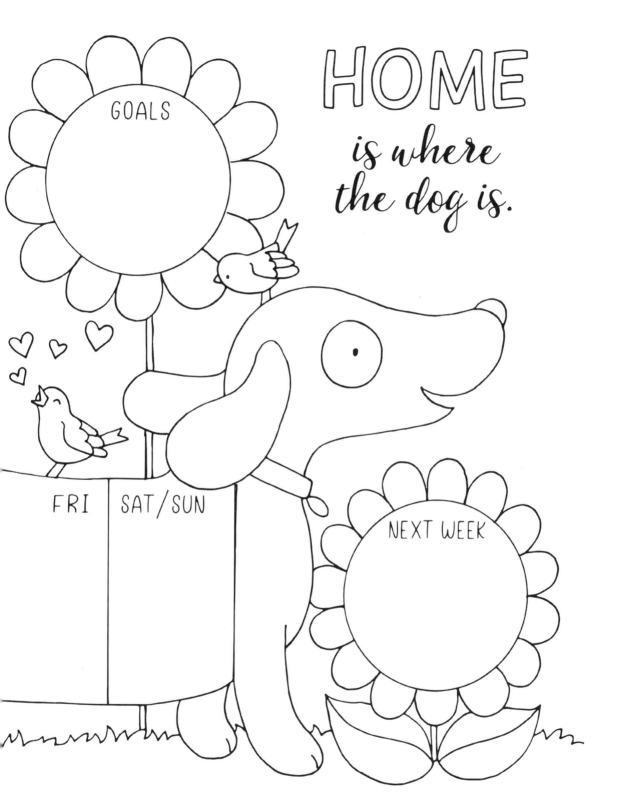

GOALS

HOME
is where
the dog is.

FRI SAT/SUN

NEXT WEEK

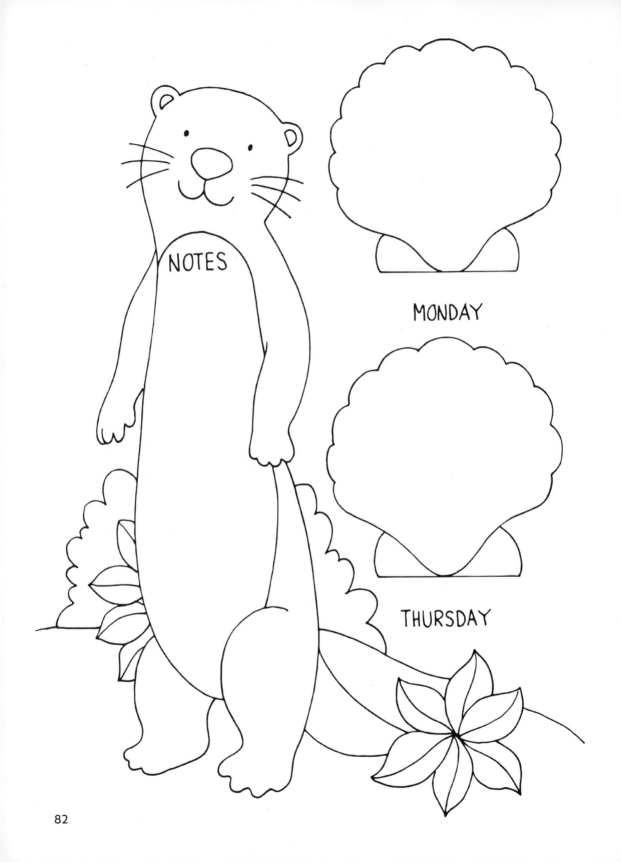

NOTES

MONDAY

THURSDAY

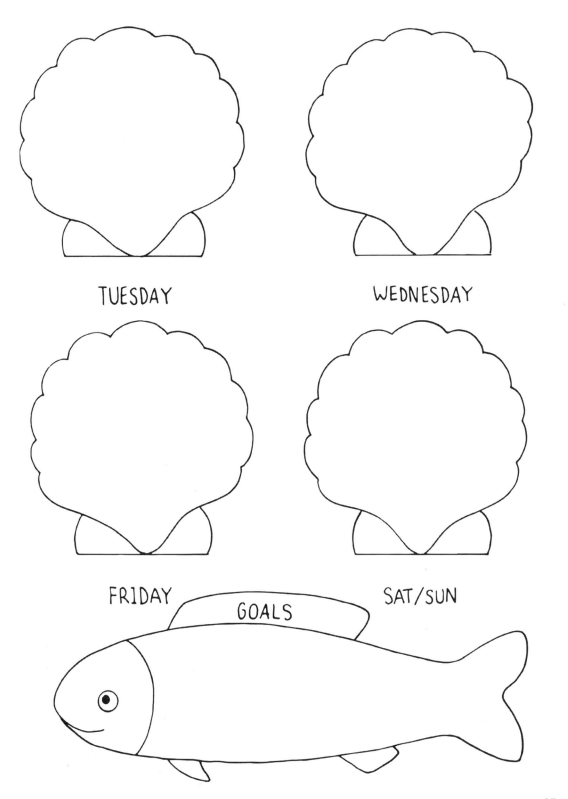

TUESDAY

WEDNESDAY

FRIDAY

SAT/SUN

GOALS

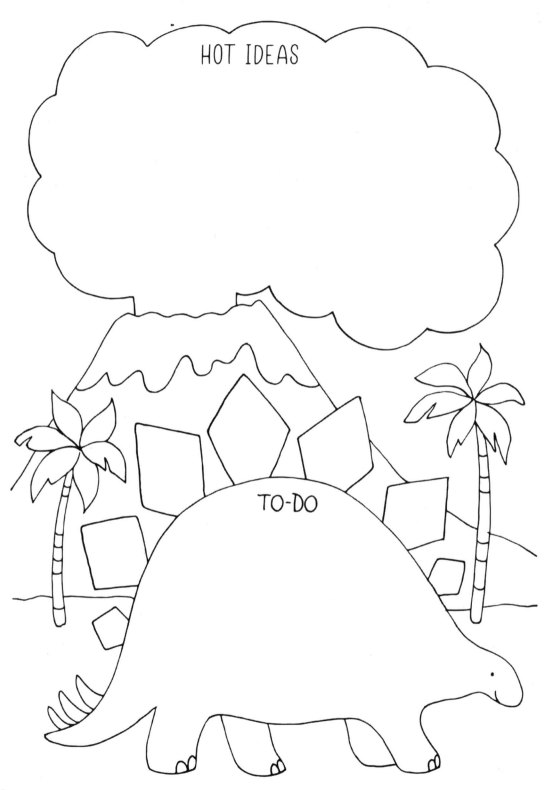

HOT IDEAS

TO-DO

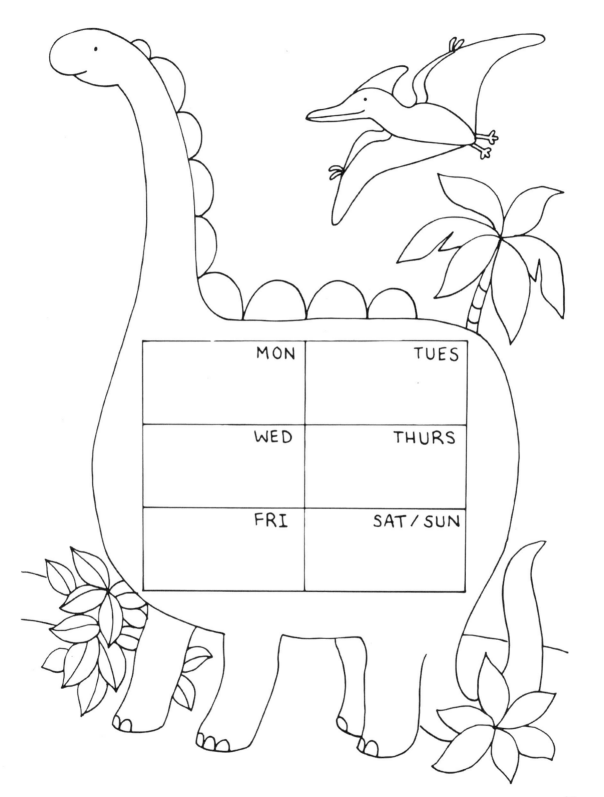

MON	TUES
WED	THURS
FRI	SAT / SUN

DEEP THOUGHTS

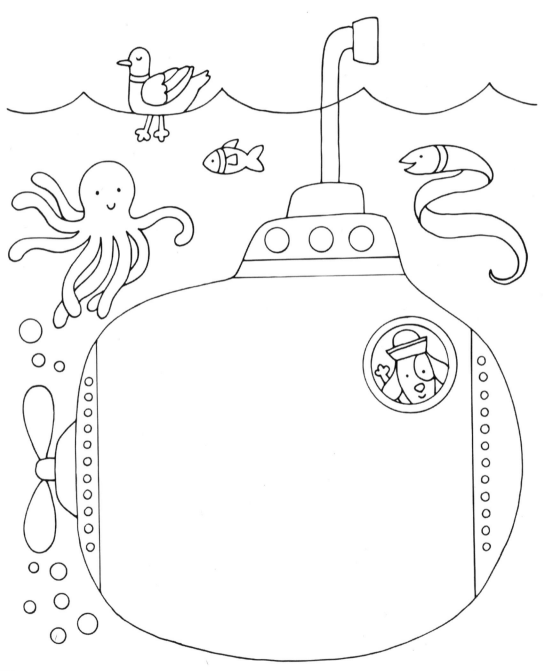

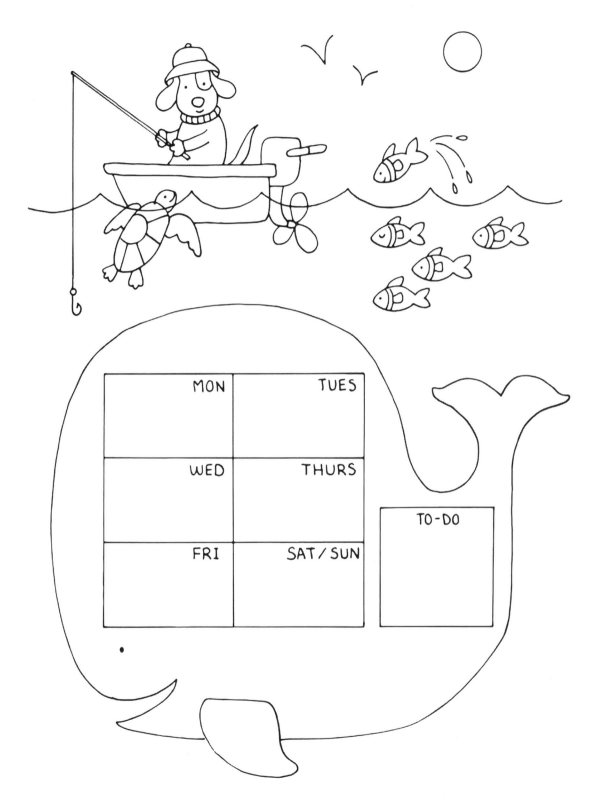

MON

TUES

WED

THURS

FRI

SAT / SUN

TO-DO

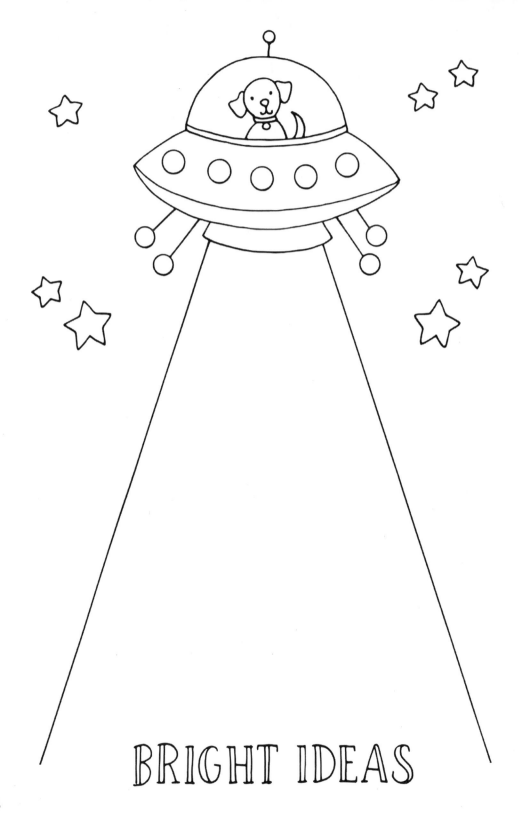

BRIGHT IDEAS

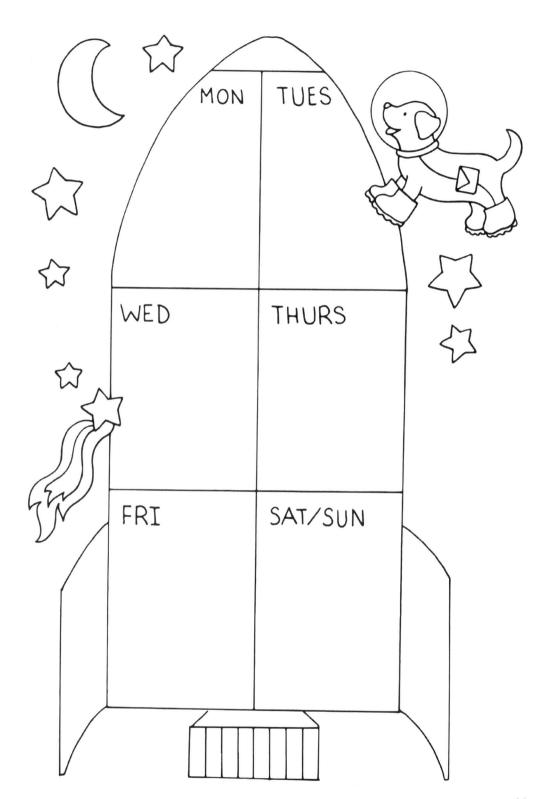

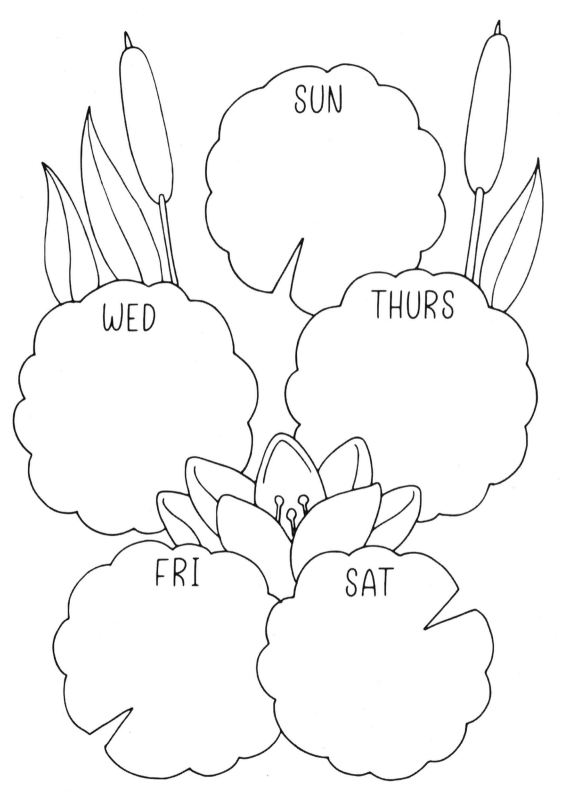

SUN

THURS

WED

FRI

SAT

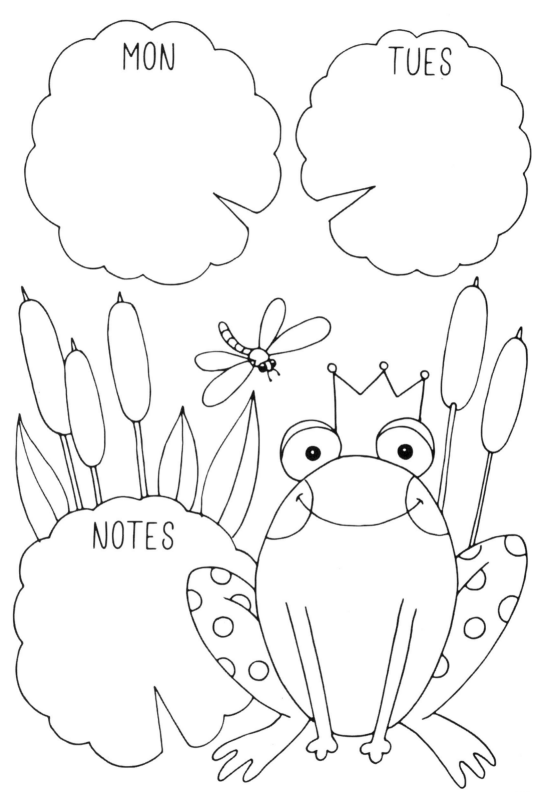

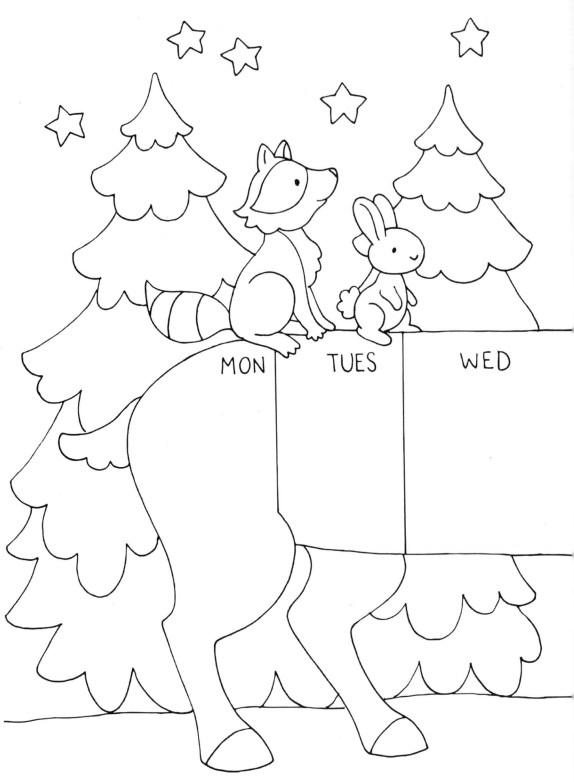

MON TUES WED

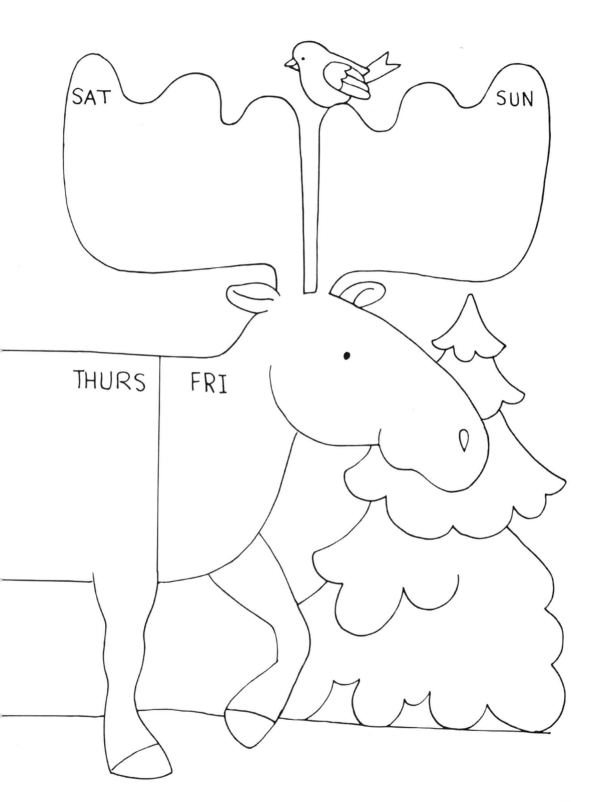

SAT

SUN

THURS

FRI

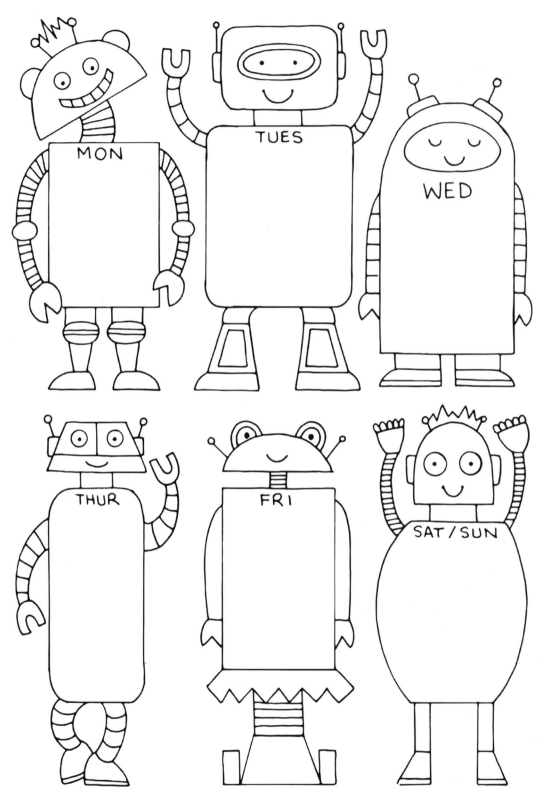

MON

TUES

WED

THUR

FRI

SAT/SUN

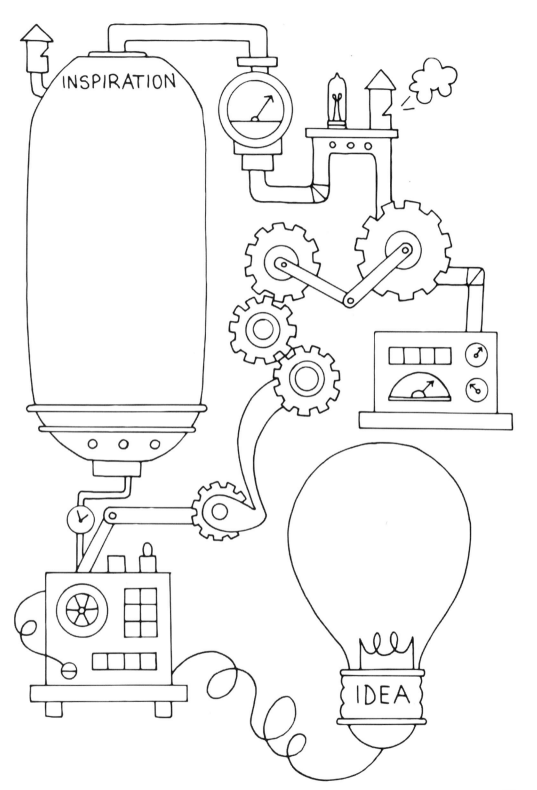

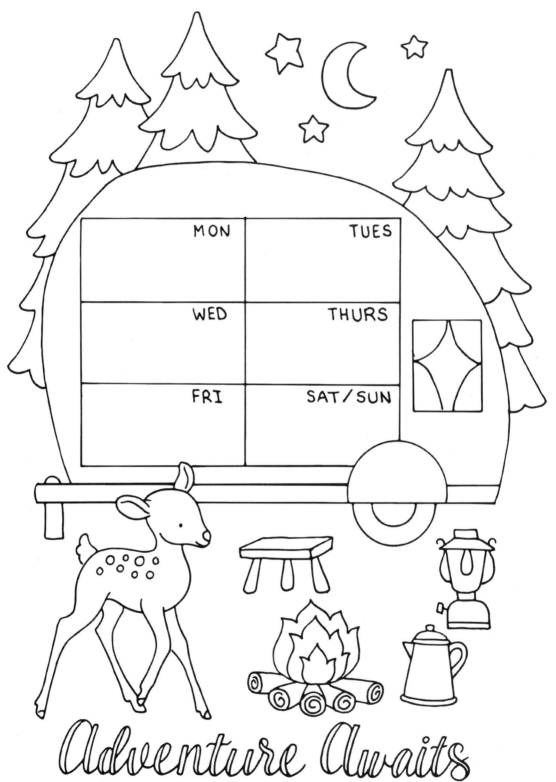

MON	TUES
WED	THURS
FRI	SAT/SUN

Adventure Awaits

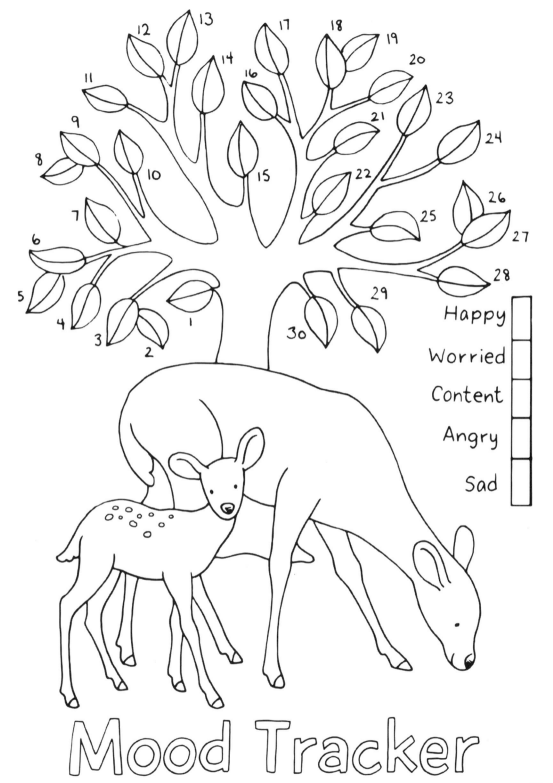

Happy

Worried

Content

Angry

Sad

Mood Tracker

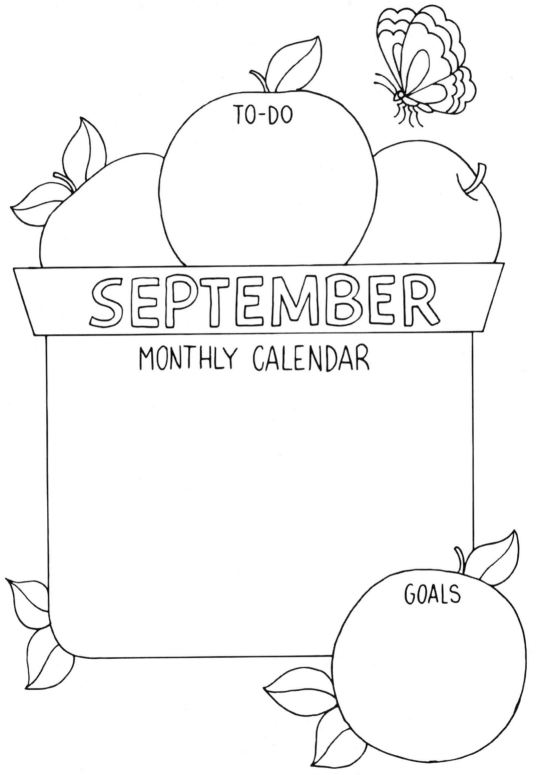

TO-DO

SEPTEMBER

MONTHLY CALENDAR

GOALS

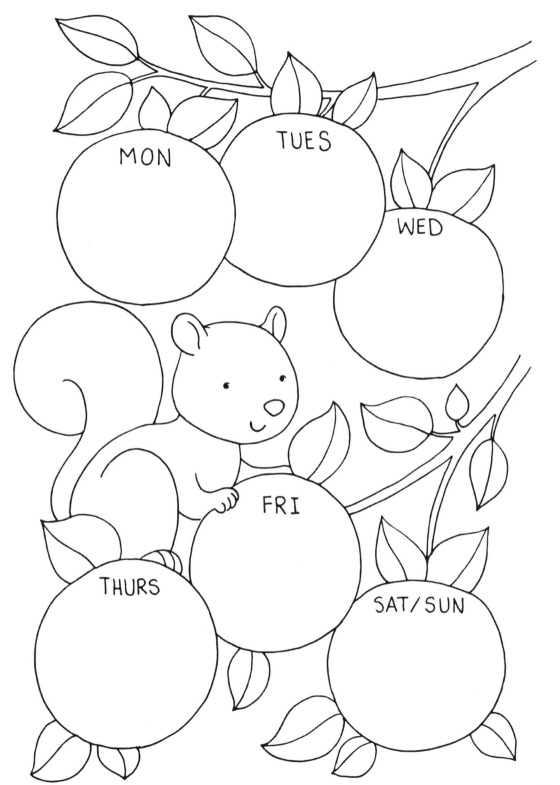

MON

TUES

WED

FRI

THURS

SAT/SUN

WRITE DATE HERE

MON	TUES
WED	THURS
FRI	SAT / SUN

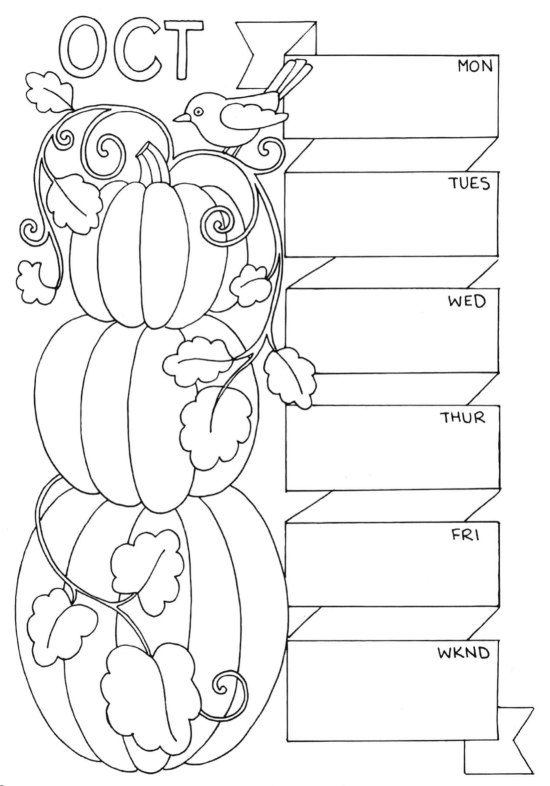

OCT

MON

TUES

WED

THUR

FRI

WKND

Mood Tracker

:)

:|

:(

1
2
3
5
9
8
7
6
4
10
12
14
15
16
11
13
21
22
17
18
19
20
23
24
29
25
26
27
28
30
31

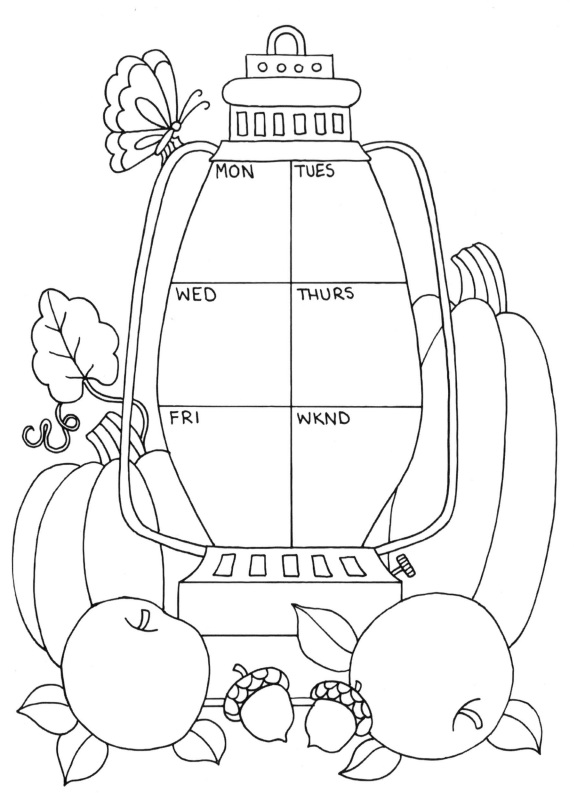

MON TUES

WED THURS

FRI WKND

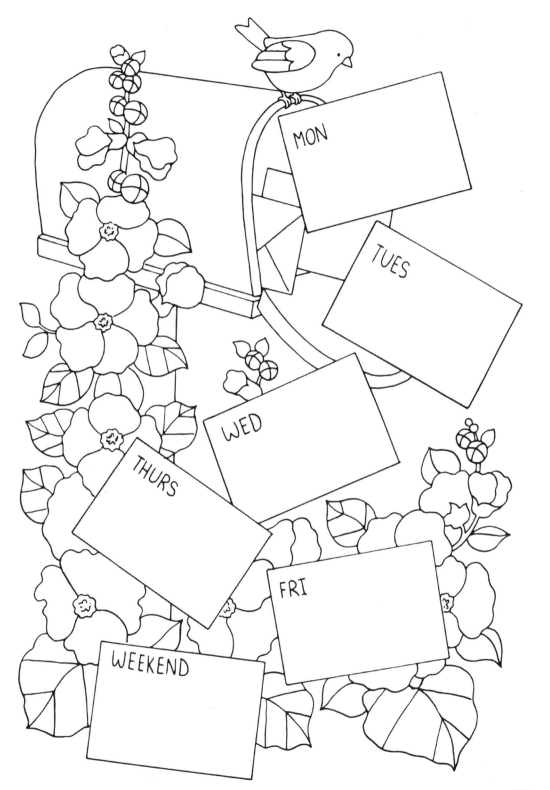

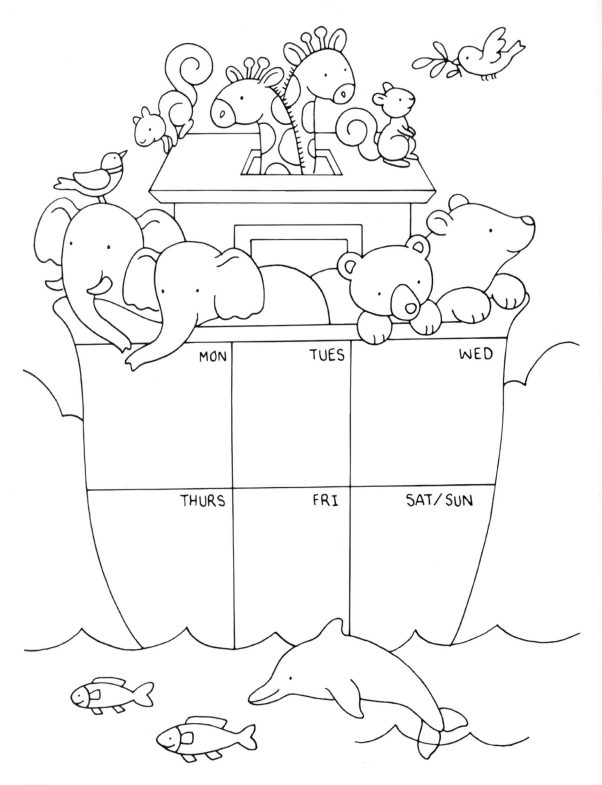

MON TUES WED

THURS FRI SAT/SUN

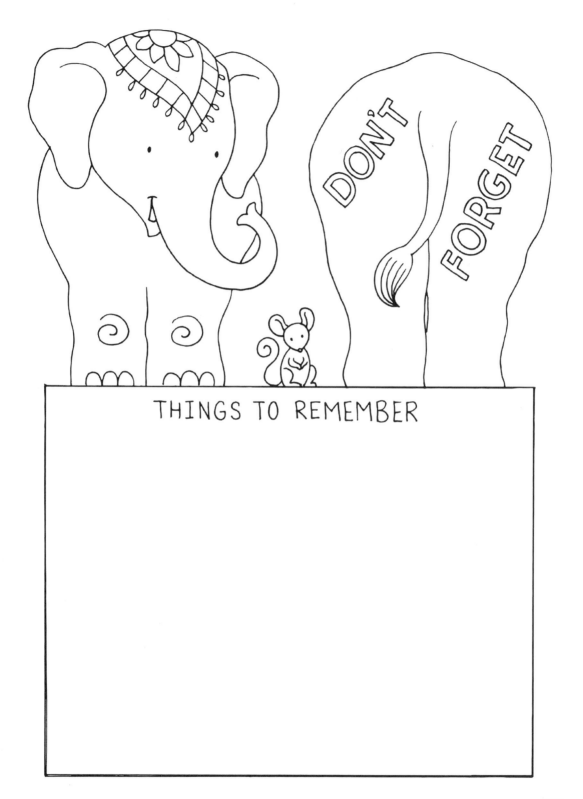

DON'T FORGET

THINGS TO REMEMBER

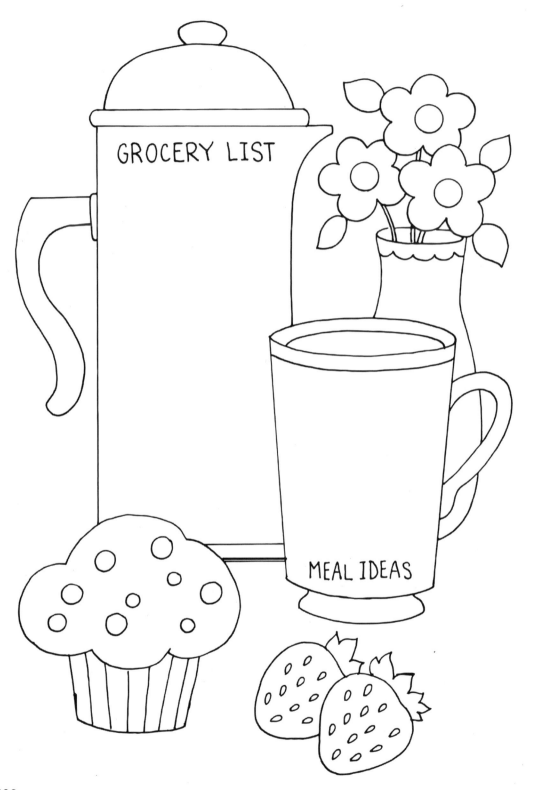

GROCERY LIST

MEAL IDEAS

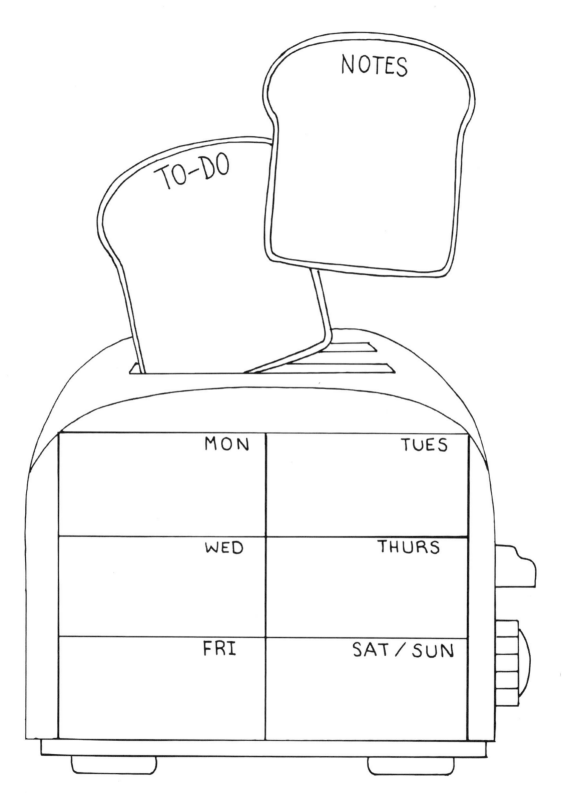

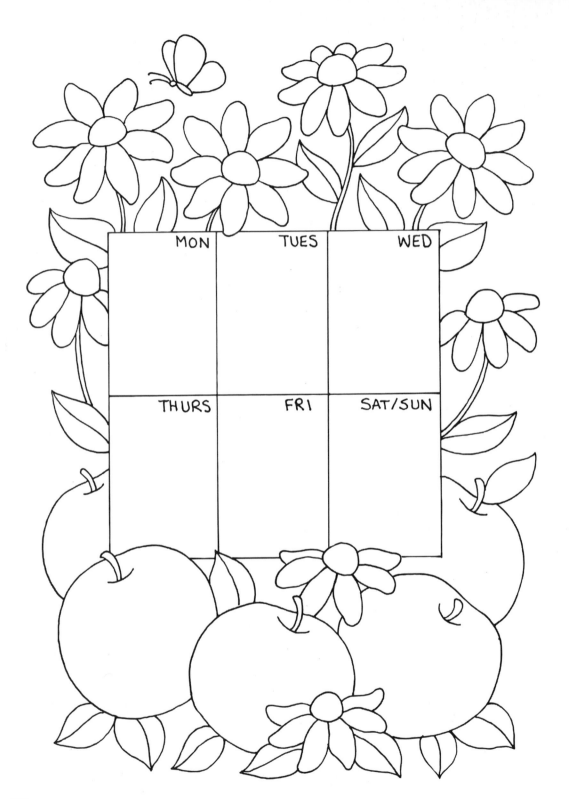

MON TUES WED

THURS FRI SAT/SUN

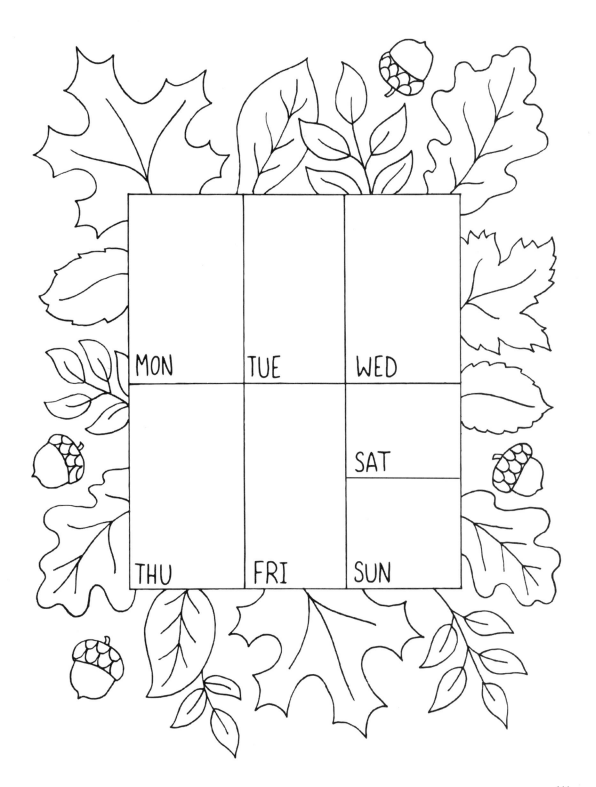

MON

TUE

WED

SAT

THU

FRI

SUN

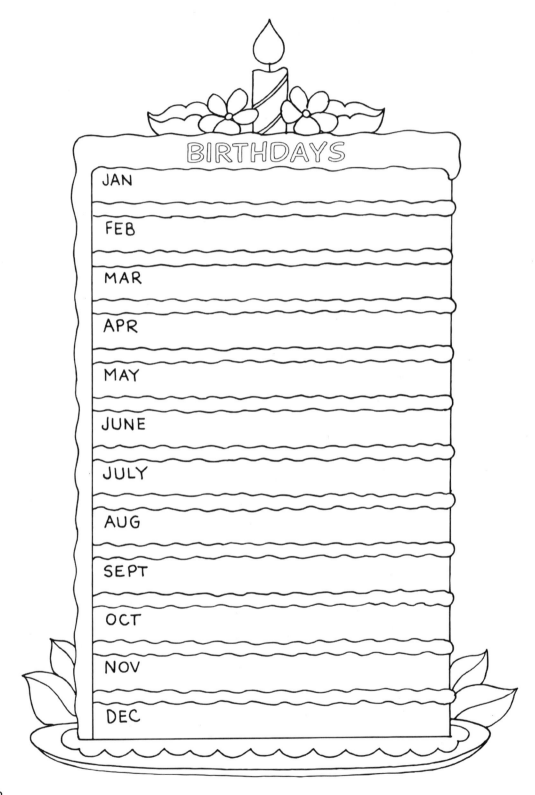

BIRTHDAYS

JAN

FEB

MAR

APR

MAY

JUNE

JULY

AUG

SEPT

OCT

NOV

DEC

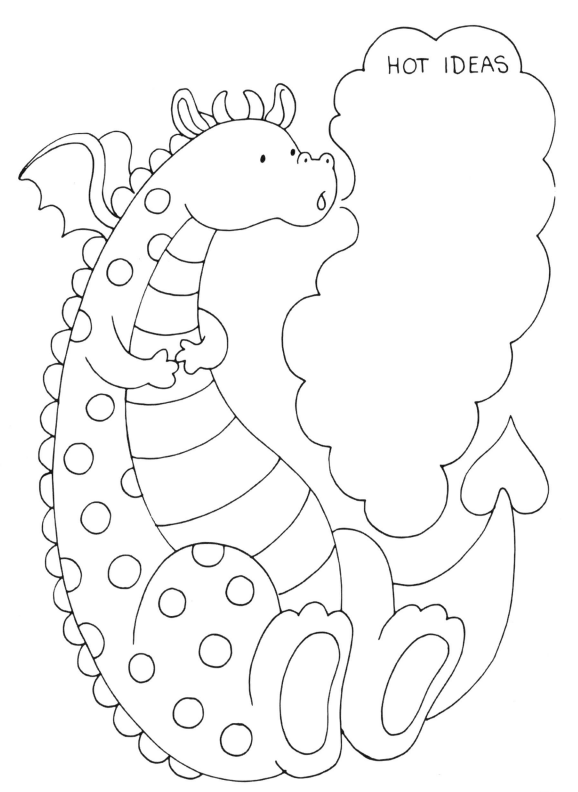

HOT IDEAS

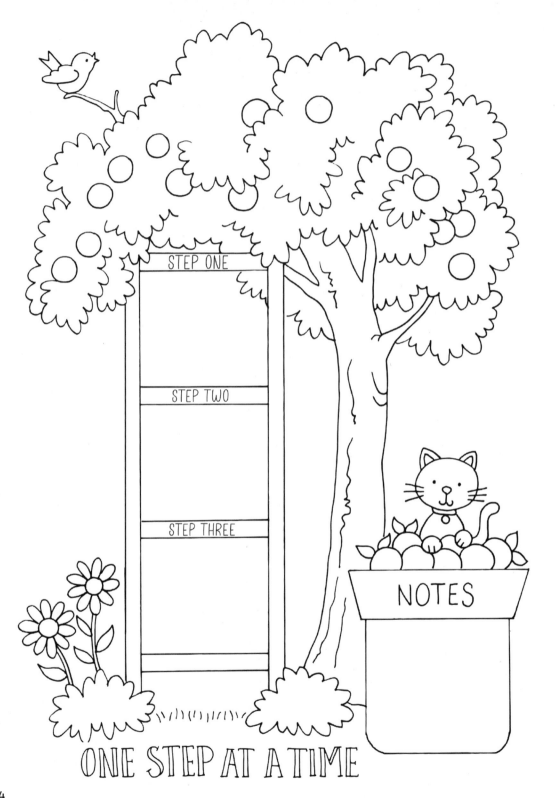

STEP ONE

STEP TWO

STEP THREE

NOTES

ONE STEP AT A TIME

SCHOOL SCHEDULE

	MONDAY	TUESDAY	WEDNESDAY	THURSDAY	FRIDAY
8					
9					
10					
11					
12					
1					
2					
3					
4					

ASSIGNMENTS

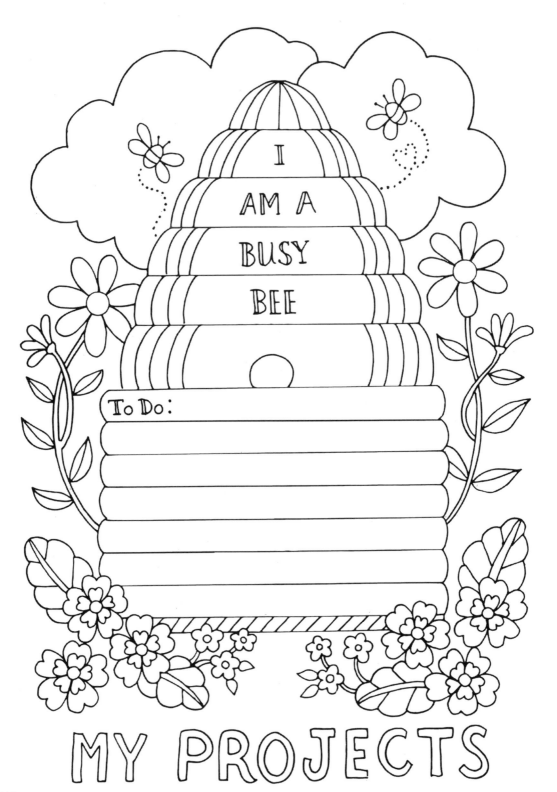

I

AM A

BUSY

BEE

To Do:

MY PROJECTS

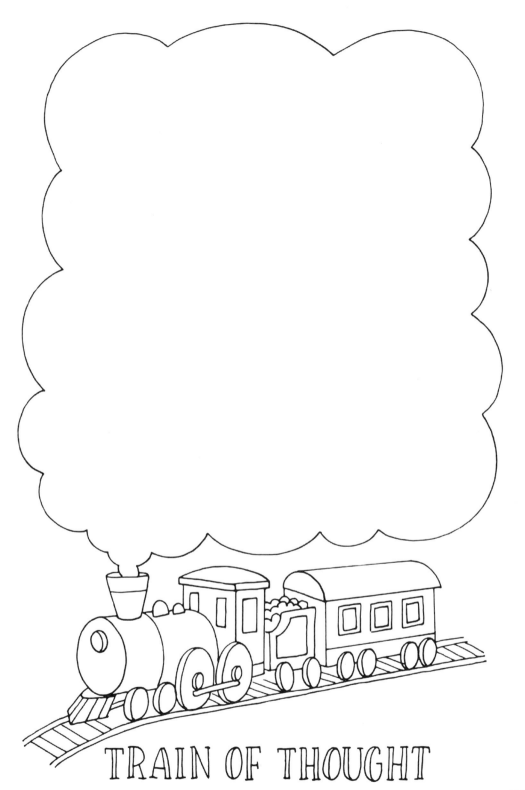

TRAIN OF THOUGHT

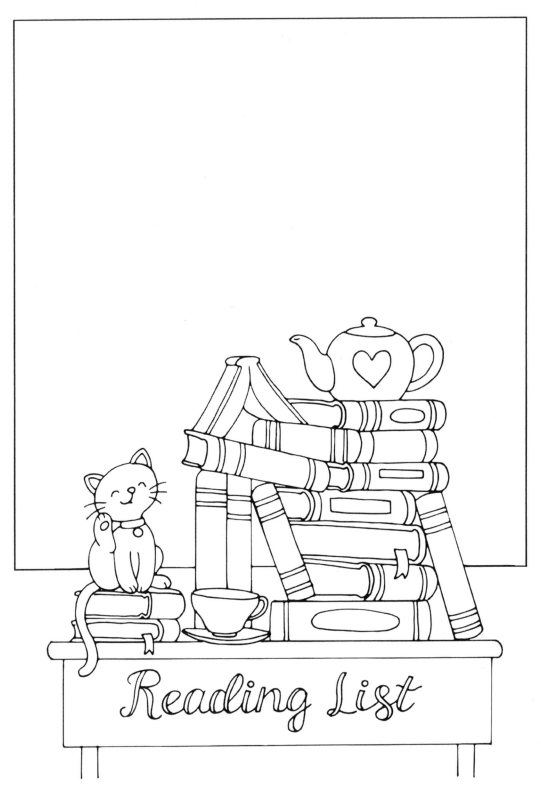

Reading List

Section Three:

Making Space
for Notes
in a Drawing

I love designing pages where I use the body of the drawing as a place for notes or other writings. The following pages will give you some examples and hopefully spark ideas of your own. Think about how you can enlarge or exaggerate a portion of your subject matter to make space for plenty of writing. Give a bear a big belly, or stack objects on top of one another. The sky's the limit (especially if you have a great big parachute or balloon!).

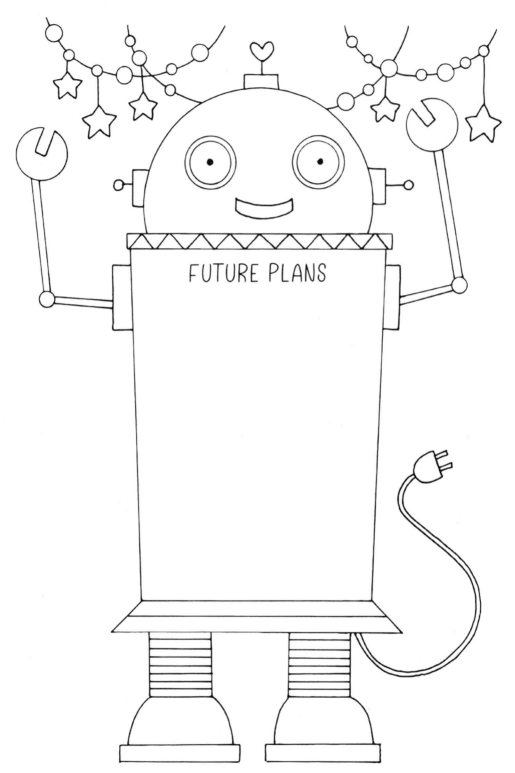

FUTURE PLANS

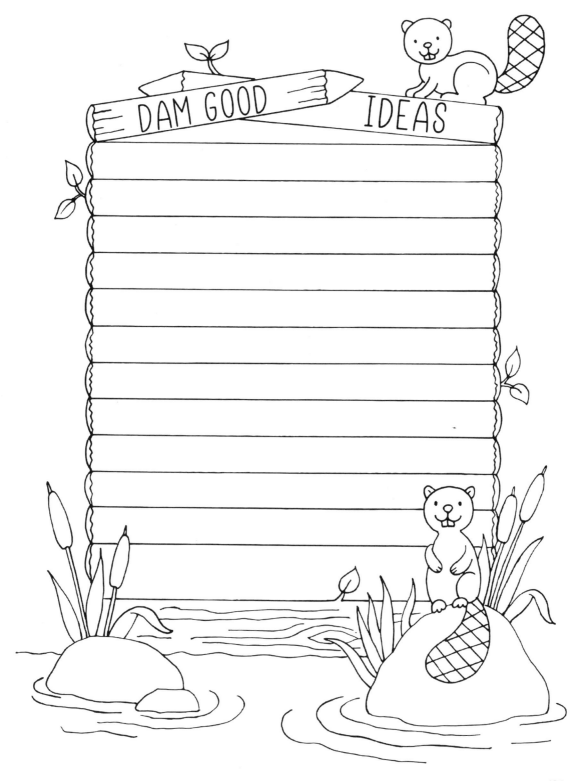

DAM GOOD IDEAS

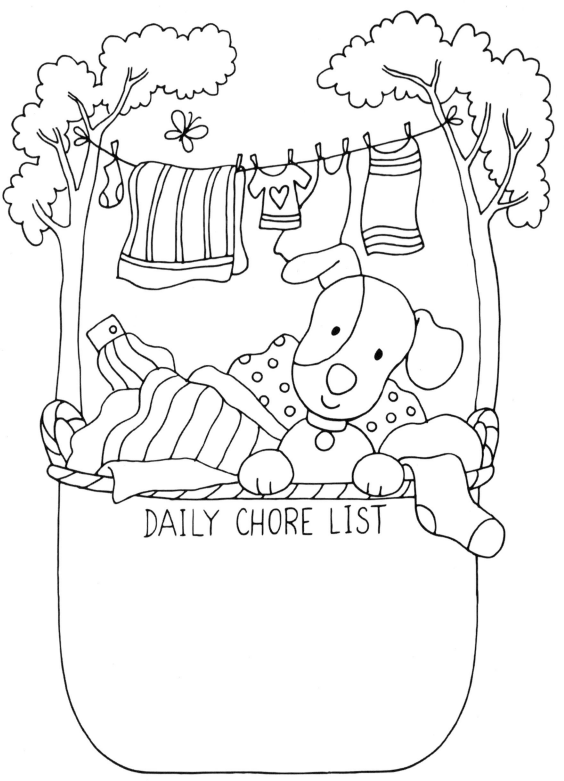

DAILY CHORE LIST

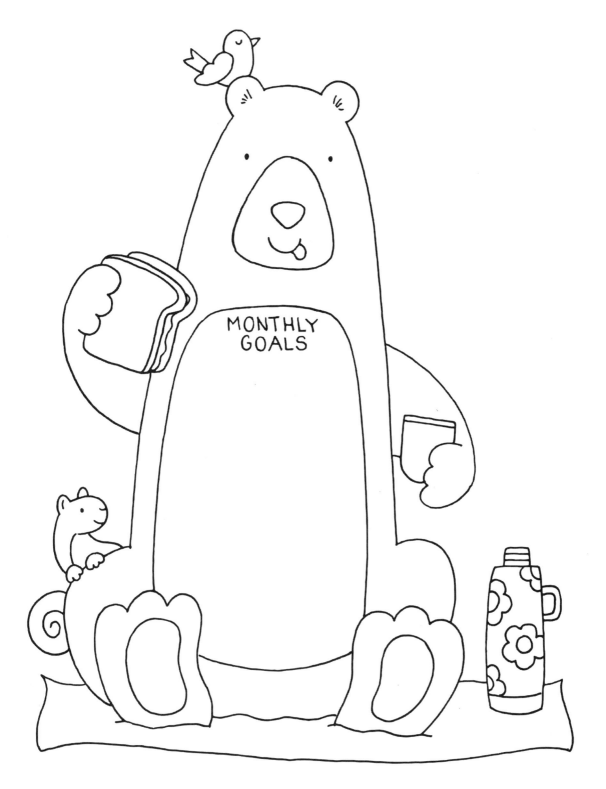

MONTHLY
GOALS

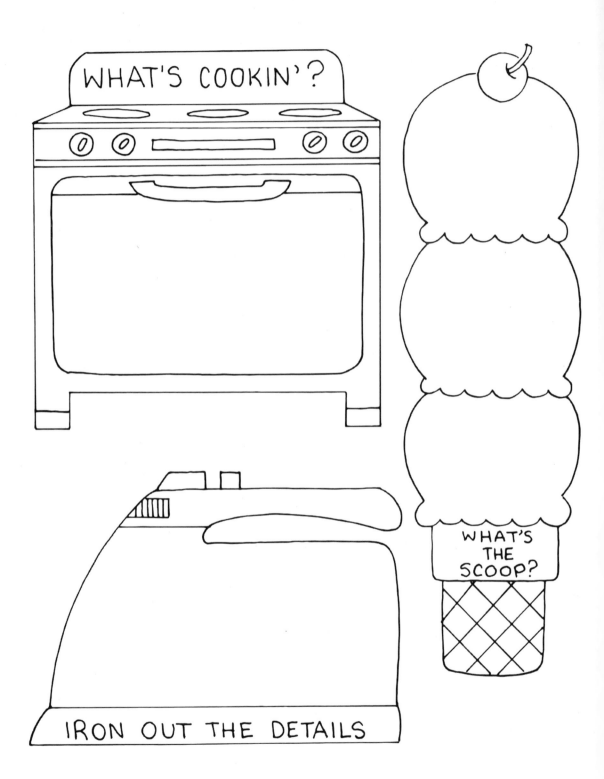

WHAT'S COOKIN'?

IRON OUT THE DETAILS

WHAT'S THE SCOOP?

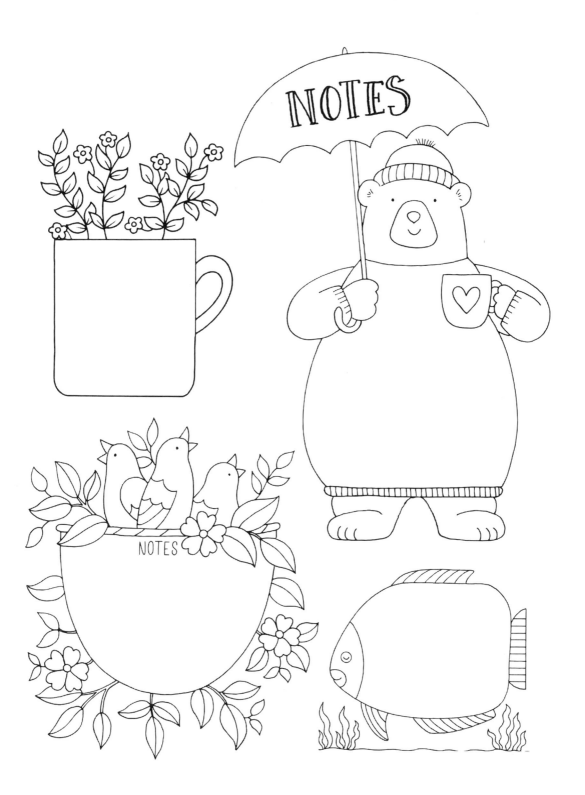

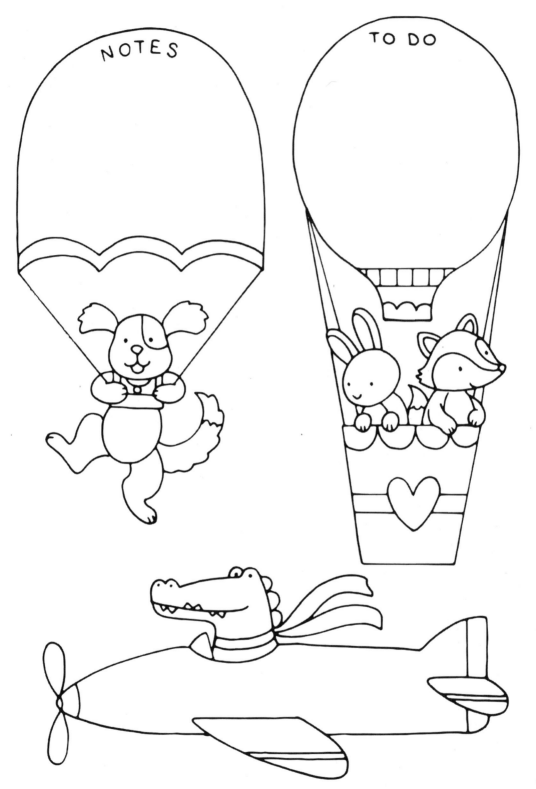

Last Word

I hope that this book has invigorated you and kindled within you a deep love of doodling and drawing. As you continue practicing, and in turn feel more confident, use your imagination and let your creativity flow. Your journal or sketchbook is a unique expression of who you are and the unlimited capacity of your creativity and imagination. Unwind and start anew every day and see where your drawings take you—you never know where you might end up.

Acknowledgments

Thank you to the gang at Penguin Random House, especially Marian Lizzi, Rachel Ayotte, and Ashley Tucker for seeing the potential in this book and helping to make it a reality.

Thanks, always, to my husband, John, just for putting up with me (and for dragging me out of the studio to eat and sleep!).

For more art and inspiration, please check out my Instagram page at www.instagram.com /janemaday.

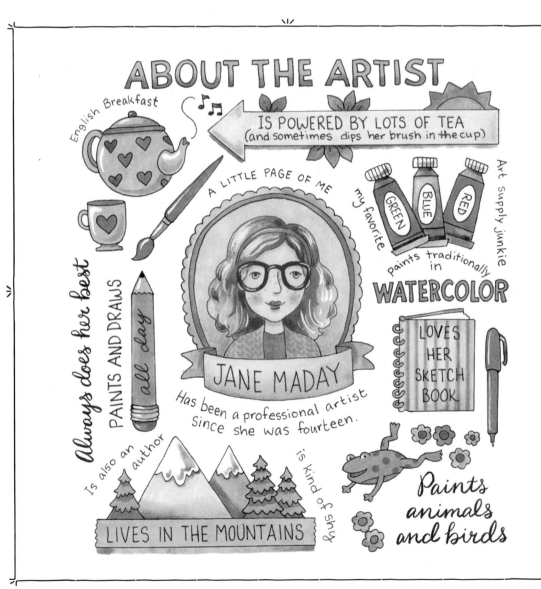